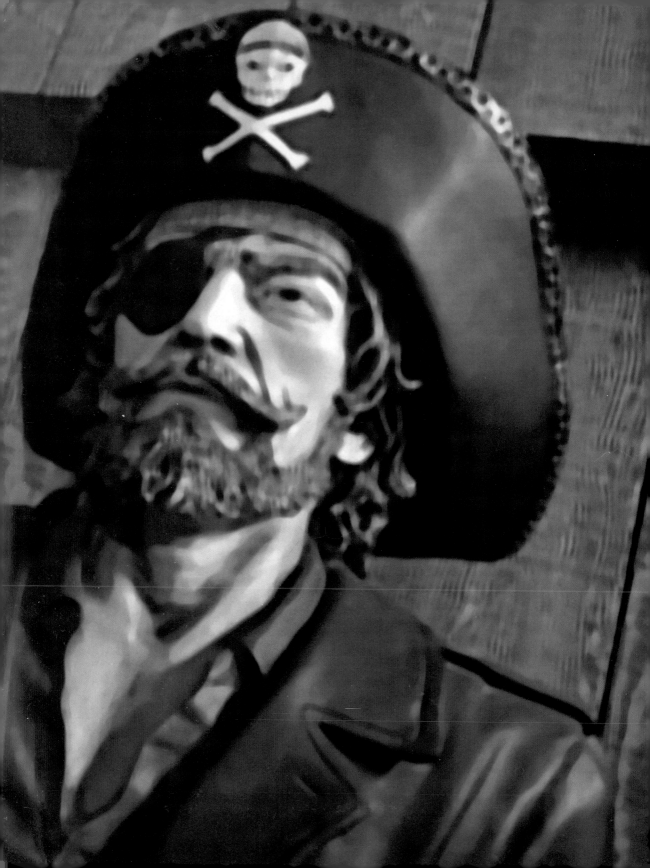

MTV'S CRIBS

A Guided Tour Inside
the Homes of Your Favorite Stars

M. M. Nathan

POCKET BOOKS

New York London Toronto Sydney Singapore

An *Original* Publication of MTV Books/Pocket Books

POCKET BOOKS, a division of Simon & Schuster, Inc.
1230 Avenue of the Americas, New York, NY 10020

ISBN: 0-7434-5174-0

First MTV Books/Pocket Books trade paperback printing October 2002

10 9 8 7 6 5 4 3 2 1

POCKET and colophon are registered trademarks of Simon & Schuster, Inc.

For information regarding special discounts for bulk purchases, please contact
Simon & Schuster Special Sales at 1-800-456-6798 or
business@simonandschuster.com

Book design by The Fold

Cover design by The Fold

Printed in the U.S.A.

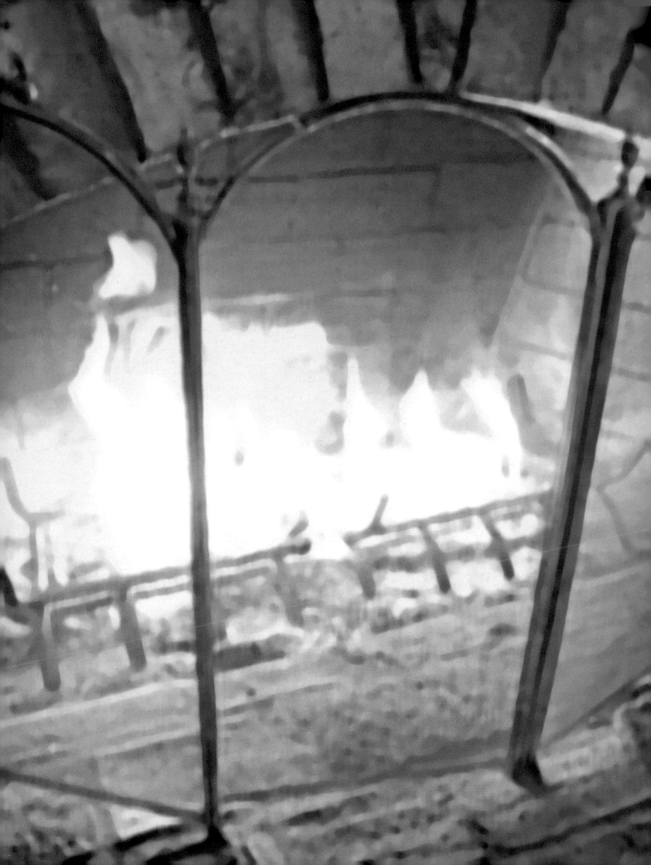

CONTENTS

BEHIND THE CRIBS

Nina L. Diaz, supervising producer: When we came up with the idea for *Cribs*, we were trying to find a way to get deeper inside the lives of MTV artists. We wondered: What were the artists like at home?

We did the pilot in four weeks. There were a ton of people we wanted to pursue, but we ended up with Fieldy from Korn, Steve Harwell from Smash Mouth, Jermaine Dupri, and Carmen Electra. We knew right away that we had a hit!

Filming an episode of *Cribs* is a long process. We have a two-camera crew including one director, one producer, a steadicam, a director of photography, and audio people. There are six or seven people who show up on an artist's doorstep. It's a lot of equipment and it takes an hour just to set up. Then we do a walk-through. Yes, that's the first time we're seeing the house. We don't know anything about it going in.

Surprisingly, most people don't have huge entourages in their cribs with them. We ring the bell expecting someone else to answer and it's usually the artist themselves.

Maty Fernandez, associate producer: *Cribs* was my first job with MTV. All I can say is: Just when you think you've seen it all, it gets even better—more outlandish and more grand. Every time a new tour comes in, I'm shocked. It's so much fun to work on a show I actually watch and enjoy.

Erika Clarke, producer: Yeah, it's a crazy job, going into people's houses and rummaging through their stuff. For these artists, their homes are their fortresses. In their own domain, they let their guards down.

I feel endeared to the celebrities who live in two-bedroom homes. I think it's good for viewers (especially kids) to see that once you record an album you don't automatically get an eight-thousand-room spread.

Toni Ann Carabello, producer: It's a bit of a bummer when you walk out of these houses and go back to your own house. I want an arcade! I want a pool! That's the worst part, but you get over it. Travis from Blink-182 had this hotel-style backyard. All I could think was: I don't even need a house. Stick me in the backyard.

Xionin Lorenzo, segment producer: Working on *Cribs* is definitely fun. You have to check yourself and keep it all in perspective. Filming *Cribs* is exhausting, especially for the steadicam guys. The camera and the rig are so heavy and they have to carry it around all day long.

YOUR CRIB IS...

Your crib is a place where you should want to go to. You should surround yourself with things that make you feel good—whether it's a soothing color scheme or collectibles you love.

Suss out what a home means to you. It can mean many things, but it should, in its essence, be a reflection of your personality.

Whether you have a huge twenty-five-room house in Bel Air or a shoebox dorm that you share with a roommate, you need to create a space of your own. How you design your own space may depend on when you find yourself at home most. Do you entertain? Do you spend time alone? Do you cook? Do you feel like your house is a place to get away? A place to hang out with friends? Or both?

Taste is driven by experience. It's not something you're born with.

You learn it. You see it on the road. You see it at your friends' houses. Julia Roth, interior designer.

The crib is a perfect laboratory to study how we live. Brock Mettz, interior designer.

Household Discoveries: *An Encyclopedia of Practical Recipes and Processes* by Sidney Morse, copyright 1914 S. L. Morse

The subject of house furnishing is more important than is often realized. It has a moral and social as well as an economic side. The relation is very close between the character, or at least the reputation, of men and their surroundings. Everyone is free to change his surroundings. Hence the furniture and the decorations of a house, and the condition of the house and grounds, are properly considered an index to the character of its occupants.

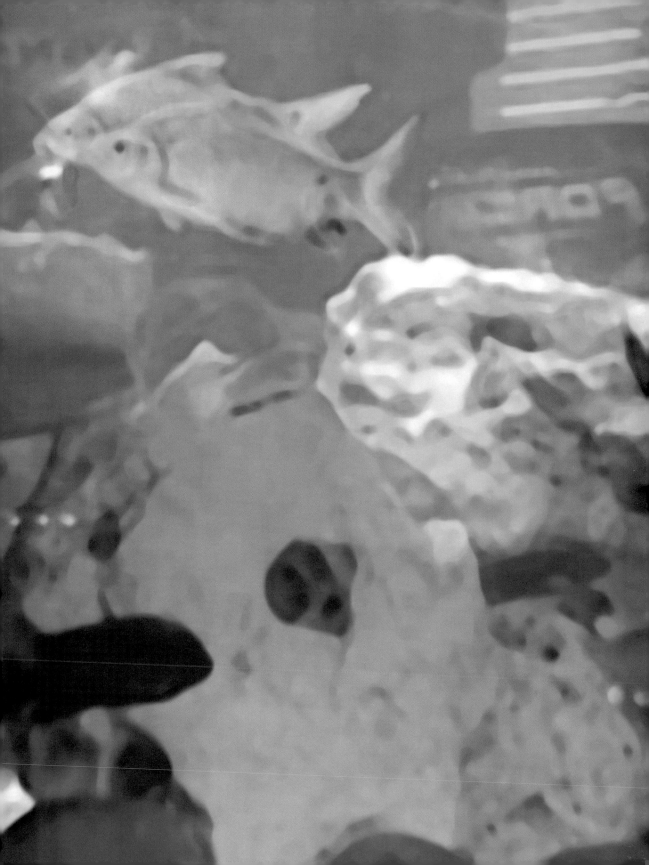

STATS
Houston, Texas
6 bedrooms
5 1/2 bathrooms
Pool/lake
Garage apartment
Moroccan room
Destiny's Child dressing room

DESTINY'S CHILD

BEHIND THE SCENES

Nina L. Diaz, supervising producer: Destiny's Child were really fun, great sports. It was the beginning of 2000, the year they blew up. They were so down-to-earth, funny, and gracious hostesses. We had a few tech problems during that shoot. We actually had to reshoot a huge part over again. I was walking on eggshells telling them, but they were great sports about it. They didn't flinch. They made us feel so good.

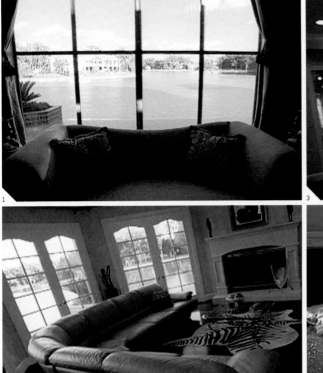

¹ **Beyonce:** We're in the home of Kelly and Beyonce. My mother lives here and my sister Solange. The reason why we fell in love with this house was this huge window overlooking the lake and the pool.

² This is our lounge area where we come and chill.

³ The kitchen. We really like to eat.

⁴ Solange's bedroom.

⌐ HOW TO

Solange's spread is like makeup for the bed. It's the equivalent of glitter eyeshadow. Some days you might want it, and some days you might not. Big cuttings of shiny fabric are great accessories for the bedroom. A bed typically is seventy-five percent of the bedroom. So, change the bed and you change the whole look of the room. It's a quick fix. You can get any fabric and drape it on your bed. It doesn't have to be born a bedspread to become a bedspread. Any dress maker will have this kind of lamé type fabric. You'll be surprised at what you can get at a local fabric house. Julia Roth, interior designer

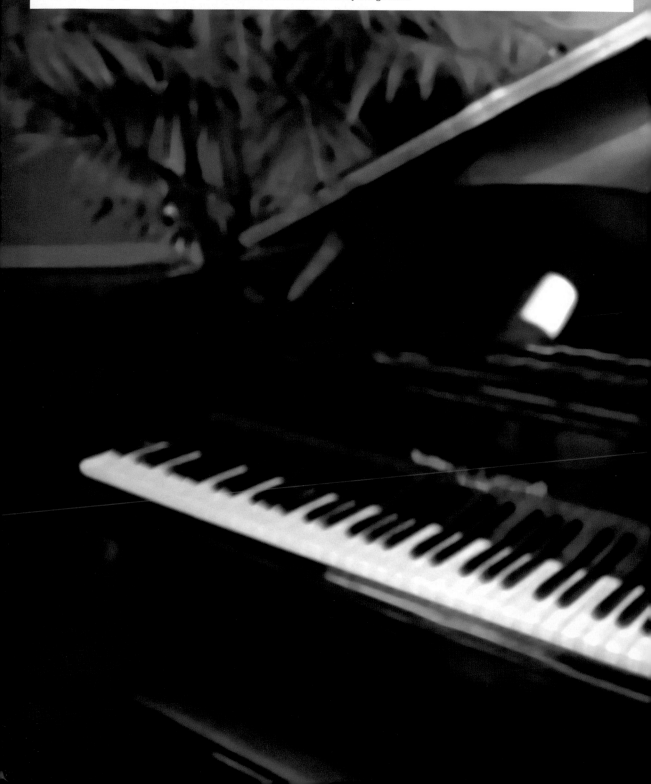

Certainly nothing signifies more than a musical instrument in the family living room.

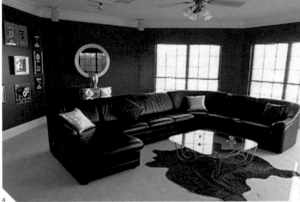

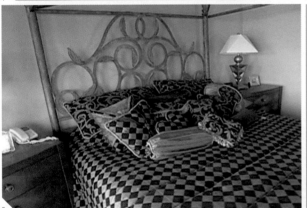

4 **Kelly:** The entertainment room, also known as the reflection room. There are a lot of memories on this wall. All these plaques give you time to reflect and think about how truly blessed we are.

5 **Kelly:** This is my room, my serenity. I call it the queen's bedroom. I'm not actually a queen, but you know. All my pictures mean a lot to me. Everyone I put a picture up of means a lot to me.

6 **Beyonce:** This is my lovely bathroom. I really love the sink. It actually tells a story. It tells "Sleeping Beauty." Once upon a time, the frog speaks to the queen etc. etc. etc. They live happily ever after.

PROFESSIONAL OPINION

Clutter makes a room look smaller—a good reason to keep memories tucked away for special moments of reflection. If you have to hang on to your past, you can file it away in a neat little hatbox. In my opinion, clutter is not a good thing. In the bedroom you should surround yourself only with things that make you feel good—no exes, no weird memories. As a rule: never have a desk in the bedroom. You never want to think about work. Julia Roth, interior designer

Beyonce creates a relaxing space using luxurious fabrics in lush colors. Purple is the color of royalty and majesty. The room is sumptuous yet calming. Your room is your universe and you should be a star in it. To make your room a getaway like Beyonce's, hang some great beads. Beyonce's using Indian saris. You could also use Chinese kimonos, African fabrics, anything textured. If you want to get Beyonce's cloud ceiling, here's what you do: pick a great flat robin's egg blue background and rag on a Benjamin Moore super white. Add a clear high gloss finish on top. You can add some glitter from the hobby shop to the glaze. At night, with candles, the ceiling will sparkle. Julia Roth, interior designer

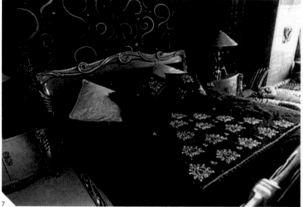

7

9

8

7 **Beyonce:** Now, this is my personal favorite room. My room is drama, very colorful and dramatized. We went and got saris from a lot of the Indian stores. All of this stuff is hand beaded. Got my bedspread custom made and designed by my mother, Tina Knowles.

8 **Beyonce:** This is my favorite piece in the room because it reminds me of a genie bottle.

9 **Beyonce:** Now this over here has to be my favorite part of my room. It's like just a place where you lay back and relax. I write a lot of my songs here. There are bricks painted on the walls and on the ceiling there are clouds painted. I love clouds. Imagine coming here just relaxing and listening to music and chilling out. It's perfect.

The pool looks like it's going into the lake. How fabulous!

STATS
Location: Florida
2,963 square feet
3 bedrooms
3 1/2 bathrooms
See-through fireplace
Fabulous ocean view

HOWIE DOROUGH

Mi casa, su casa. . . .
So, come on in.

BEHIND THE SCENES

Erika Clarke, producer: Howie owned the complex he lived in and bought it as an investment. We drove up and I was a little worried that maybe it wasn't going to be much. I was wrong. He was right on the ocean.

Howie's very proactive in his own home and that's nice to see. His mom and his brother were there. He was so accommodating and so sweet. There were fans waiting to meet him who were totally smitten.

He seemed very grateful for everything he had. He seems humble and doesn't take stuff for granted. He was a doll.

1 This is my little wall of fame here.

2 This is our foyer as you'd call it. My interior decorator and I decided to do this copperish tone to go well with all my Backstreet Boys awards.

3 This is one of my favorite places in the house. I love tropical fish. When designing this place, I told the interior decorator I wanted a fish tank to go through the whole place.

4 The place that's closest to my heart, the kitchen.

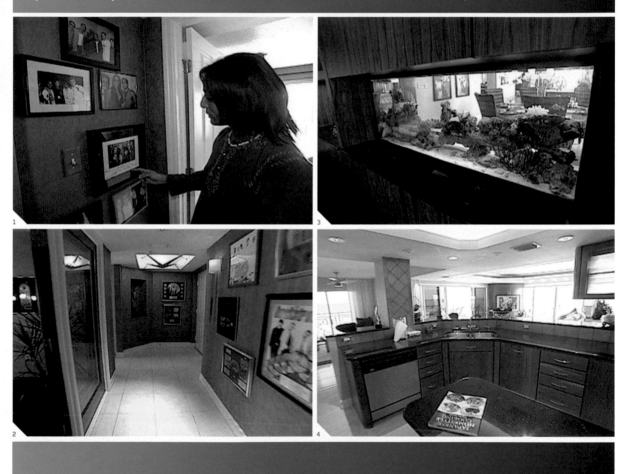

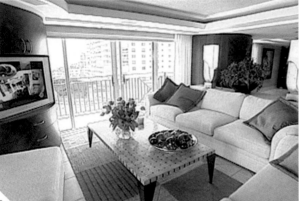

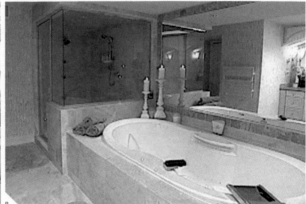

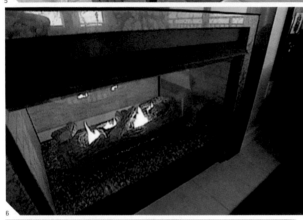

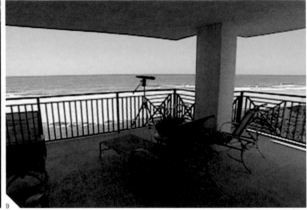

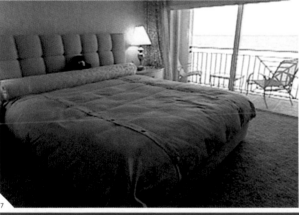

5 This is the lounge room. This is the area where I like to think of laying back, maybe lounging, turning the candles on, becoming a little romantic.

6 The fireplace is something I had to have strategically in the house where I thought I could get the most use out of it.

7 This is the king ding bedroom suite.

8 The great master bathroom. I'm very proud of it.

9 This is where I spend a lot of evening hours. It's where I become at peace with the ocean.

HOUSEHOLD DISCOVERIES: CIRCA 1914

As the muscles are entirely quiescent during sleep the body generates much less heat than in waking hours. Hence, the bed-clothes should furnish greater warmth than the ordinary clothing. On the other hand, the bed should not be warm enough to interfere with normal evaporation or overheat the body so as to cause undue perspiration.

MOBY

Here is my nice home on the Lower East Side of Manhattan.

BEHIND THE SCENES

Nina L. Diaz, supervising producer: Moby's space is very utilitarian. He didn't have a shower curtain or a mirror in his bathroom! He told us he didn't feel the need to look at himself in the morning. He said guests always commented on it.

He was so happy with his place. He'd been in that neighborhood for a long time. That was one of the first New York City apartments we did on *Cribs*, which was funny since we all live in New York. It was cool for us to see how other people lived here.

[1] There are two things about my bathroom that seem to confuse a lot of people. One is that I don't have a bathroom mirror. I'm not making any profound artistic statement. It's just I moved in, and I never got around to getting a mirror. I got accustomed to not having a mirror. The other is that I don't have a shower curtain. When I'm taking a shower, the sun comes through the skylight and I can stand here and I can take a shower with the sun all over me. That's kind of rare in New York.

PROFESSIONAL OPINION

I commend the restraint shown in Moby's living space. It's not overtly minimalist, but simple all the same.

It's great that there's no bathroom mirror. Most bathrooms are luscious, corporeal events—especially rock stars' bathrooms. This is sparse, but not clinical. Although the light above where the mirror should be has an insane-asylum vibe to it, the space still seems warm. I like the tiles. See how they have a running brick pattern? That's a great Fifties modernist look that you can achieve with simple materials.

Moby's kitchen is remarkably simple. Using seemingly inexpensive parts, he has created a sensible and well-designed space. His table is terrific and the Eames chairs go with it perfectly.

It seems that Moby's utilizing a concrete floor, which is perfect for an industrial space and creates a great backdrop for furniture with Danish modern flair. You can actually get the mid-century modernist look through good thrift-store shopping. Look for Eames or Saarinen or Wegner. Moby could have achieved this look as a careful shopper or by spending a lot of money.

Moby's got a small bedroom and I think that's a good thing. Small bedrooms can be cozy and nice refuges from large, open spaces. I think his books are organized in a restrained, nonshowy way. They are clearly used.

The longer one lives without unnecessary furnishings, the more he is likely to appreciate the wisdom of simplicity. And if you want this look, keep in mind: No knickknacks is a very good thing. Perla Delson, architect

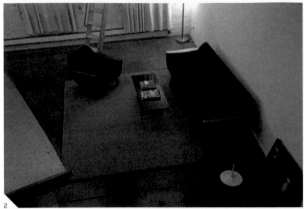

2 Here's my living room. It might look sparse and minimal by most people's standards, but for me this is actually a lot of furniture. I've got my Charles and Ray Eames coffee table that I actually found on the street and my nice Norwegian early Sixties couch and chair. My favorite piece of furniture in the whole wide world is a side table by the architect [Eero] Saarinen. He's the man who designed the St. Louis (Gateway) arch.

3 I'm very proud of my refrigerator. We had to import it from Denmark, because it's the most energy-efficient refrigerator in the world—unless they're lying to me.

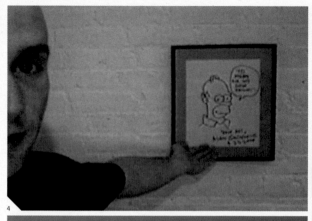

⁴ Possibly the nicest thing in my apartment, I have my personalized portrait of Homer from Matt Groening to me. If there were a fire in my apartment, and I had to grab one thing to save, I'd probably grab my picture of Homer.

⁵ I'd been looking forever to find a decent table and I ended up finding this, a restaurant supply table. The irony is that I'm a pretty strict vegetarian and this is the sort of table that they'd use in a restaurant to chop meat on.

⁶ Here is my nice soundproof studio. This is the room where I pretty much do everything. I write my songs in here. I record them in here. I do all the mixing. I do all the production. I'll come in here and play guitar or keyboards. It is a really nice place to work. My studio is really quiet, especially if I'm working at four or five o'clock in the morning. The city feels really peaceful and that's when I get the best work done.

PROFESSIONAL OPINION

Restaurant supply stores are great places to get industrial pieces and stainless-steel furnishings, not to mention terrific dishes and flatware. In New York City, these stores are located in the Bowery. I imagine that's where Moby got his great table. Julia Roth, interior designer

PROFESSIONAL OPINION

It's a rare thing to have as much outdoor space as Moby has in New York City. Clearly he hasn't had time to furnish it. I would get a couple of oversize mattresses outfitted in rubber, a picnic table for takeout, and a giant tree. It'd be an amazing place to hang out. Julia Roth, interior designer

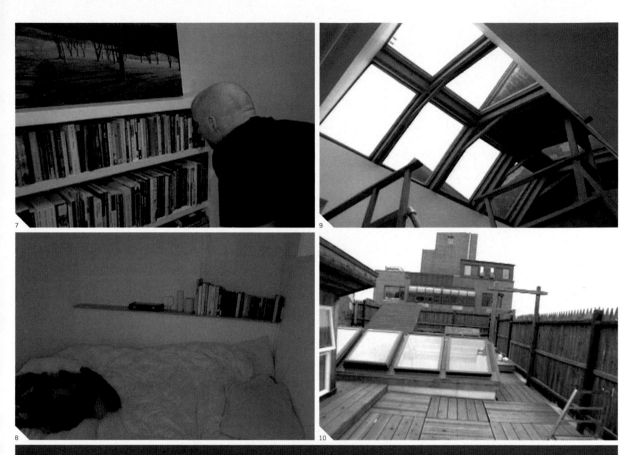

7 I've watched some of these MTV *Cribs*, and the thing that seems strange to me is that it doesn't seem like anyone has a bookshelf. It kind of concerns me that nobody reads anymore.

8 This is my sleeping area here.

9 If I were prone to New Aginess, I'd say this was the spiritual center of my home because of the cathedral ceilings. By New York standards, this is really rare; to have a quiet space with all this light.

10 My roof deck area. I should do something with it, but I've basically been on tour for the last two years and I haven't had the chance to. I still come up here every now and then, especially in the summertime. I'll sit here with friends and we'll watch the sun come up.

STATS
Staten Island, New York City
2 bedrooms
2 bathrooms
Home studio
Dollar box
Sleeping cousin, Sugarbear

REDMAN

BEHIND THE SCENES

Nina L. Diaz, supervising producer: The day we did Redman we had no idea what we were getting into. We were just as surprised as our viewers to see a broken screen door and a sleeping artist who told us to wake him up when we had the cameras on. We enjoy the element of surprise.

He knew how to turn it on for the camera.

That mess was real. It was a well-developed mess. One of his gold albums was propped up against the bathroom door. There were no sheets on his bed.

He had his cousin sleeping on the floor. That was the fastest Crib we've ever shot. Four hours is usually the minimum it takes to film a segment. Redman had a doctor's appointment to go to so we shot the whole thing in under an hour. We knew it was going to be a classic.

This is the apartment of a brother doing his album.

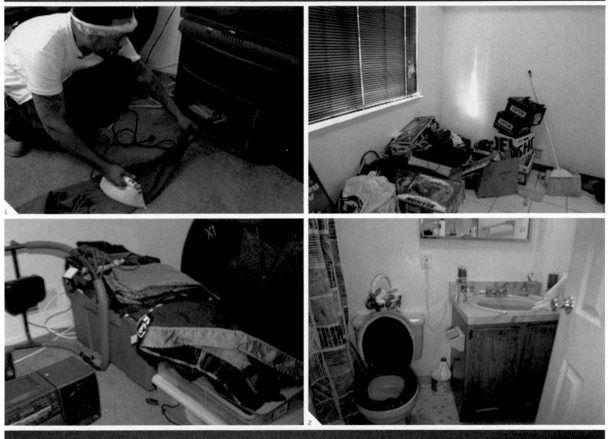

[1] Over here is what I call Exhibit A. This is where I got my clothes and crap. Got my ironing board right here. We iron on the floor. It's easy. And I watch TV at the same time.

[2] Over here, we got the *de la casa* bathroom.

HOUSEHOLD DISCOVERIES: CIRCA 1914

Place a bowl of quicklime in a damp pantry, cupboard, or closet. This not only removes dampness, but kills all odors.

The vibe I'm looking for in this apartment is bachelor's crib. He ain't running to the hills buying a big crib away from his 'hood.

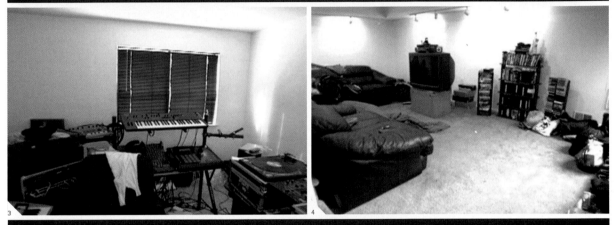

3

4

³ In here is where most of the funk, the beats, the rhymes, the ideas start up. Everything is right in place where I need it.

⁴ I like staying right here in the crap. It keeps me moving. You know how the walls and lights and stuff are going around? This is really handcrafted for me and my boys.

PROFESSIONAL OPINION

Clutter isn't a bad thing. It's how we live. I commend Redman for embracing his mess. Brock Mettz, interior designer

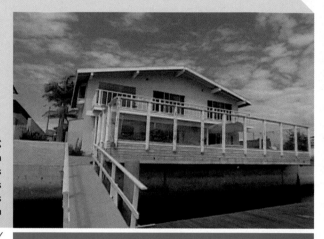

STATS
Location: Huntington Beach, California
4 bedrooms
3 bathrooms
Many Buddhas
Knickknack room

JAIME PRESSLY

I love feathers and cushiony stuff.

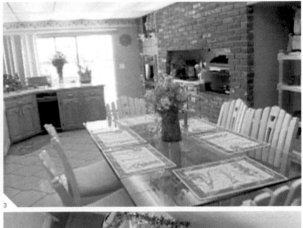

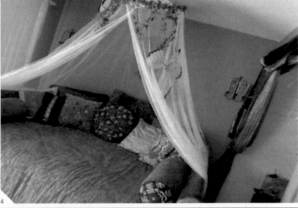

1 This is one of the many Buddhas. I've got like, eight hundred of them. I'm trying to keep the peace.

2 When I started out, I had one feather pillow. I swore up and down that when I made money, all my furniture would be feathers so that everything's cozy.

3 I go every Saturday morning and buy flowers for the house.

4 I like to call it the bohemian bed. It's like a couch-slash-bed.

HOUSEHOLD DISCOVERIES: CIRCA 1914

The best feathers for beds and pillows are plucked from live birds. Chicken, goose, or duck feathers may be preserved and used for beds or pillows by putting all the soft feathers together in a barrel as they are picked. Leave the barrel open to the sun and rain and, simply cover it with an old screen to prevent the feathers from blowing about.

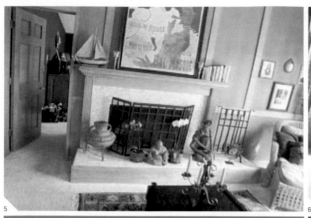

5

6

⁵ This is what I call the knickknack room. All the stuff that doesn't fit anywhere else, I put in the knickknack room.

7

⁶ This is the bedroom. I decorate the bedroom to swallow you up and allow you to sleep for hours and hours and hours.

⁷ The best part about waking up in this house is opening the curtains.

Jaime Pressly's Design Tip
There's nothing more romantic than having a fireplace in the bedroom.

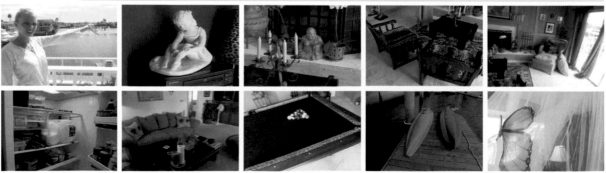

Sunlight in Rooms—Rooms can be so treated as to seem higher or broader than they are, the amount of light can be increased or subdued, and each room can be given a distinct tone and individuality appropriate to the uses to which it is put.

STATS
Los Angeles, California
Mediterranean-Spanish style
3 bedrooms
3 bathrooms
Shirley Temple memorabilia collection
Bar
Pool
Waterfall

MELISSA JOAN HART

BEHIND THE SCENES

Erika Clarke, producer: I've definitely gotten ideas for my own house from the cribs we go to. I really liked Melissa Joan Hart's house. It looked small from the front, but it's huge—with a beautiful view. She and her mom did a lot of decorating.

¹ I collect a lot of art. This statue represents *Sabrina*. When I first started *Sabrina*, I had no money and I really wanted this statue. So after a year, *Sabrina* became a hit and I went back to Hawaii and bought my favorite statue.

² Here's some of the sheet music from Shirley Temple. "On the Good Ship Lollipop," that's the best one. And she actually signed them for me.

³ My many Shirley Temples. My office is a little scary for two reasons—'cause it's either pictures of me or Shirley Temple.

⁴ Here are the lemons for my gin and tonics.

📄 PROFESSIONAL OPINION

Those lemons really work with those walls as they're golden hued. The lemons add color; they function the same way as fresh flowers, but are lower maintenance. You can choose different kinds of fruits or in the fall, gourds in different shades. Melissa Joan Hart has used her refrigerator as a personal canvas. Why not? She's not relegated to magnets. She's using magazine clippings. You can use anything. Brock Mettz, interior designer

My kitchen: I've got a pineapple for welcoming people. I love the green marble. There's lots of light. There are skylights. There are windows. My paper towel holder is my old doll. I didn't know what else to do with it. It seems to fit pretty well. My fridge, on the front I've got every ripped-out thing from a magazine I've ever loved. Like: *Is it still called breakfast if you didn't go to sleep?* Or: *Don't be scared.* When I first moved into my house, I was used to living in an apartment; it was pretty freaky.

HOUSEHOLD DISCOVERIES: CIRCA 1914

A symbol of hospitality, the pineapple was the most exotic of the tropical fruits that sea captains brought to the colonies from the West Indies. Upon returning from a long trip, a captain would spear a pineapple on his gate, letting people know he was home and that all were welcome.

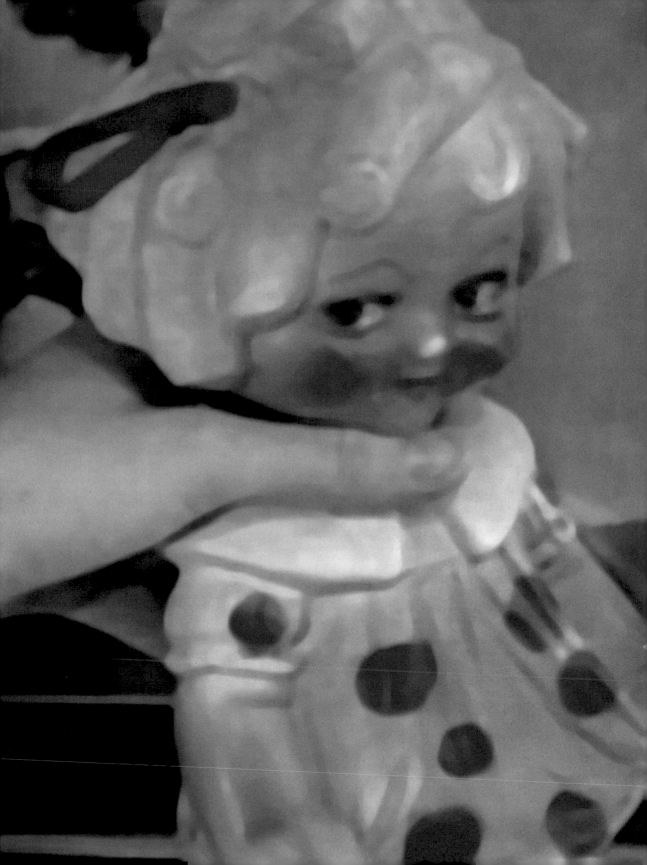

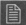
Melissa Joan Hart has framed old sheet music. You can frame just about anything, especially if you're on a budget. Pieces of vintage fabric, old magazines, a beloved old T-shirt, fronts of cereal boxes, old postcards. If you get stamps from every country you go to, you can make a thing of stamps and frame that. Or go to a local hardware store and get paint chips, arrange them on a square and you have a colorful piece of art that's virtually free—make a checkerboard pattern, whatever—it's modern art. Brock Mettz, interior designer

5 Here's my bedroom. It still needs a little work. Up around the bed I've got all my Picassos. I've got the self-portrait in the center and I've got one on each side.

6 If I had to save anything in a fire, it'd be this. This was the music box my grandmother used to play for us.

7 Wanna see my closet? It's a little scary right now.

8 This is the hangout room. We've got the bar, the fun area. If you look above it, it's got a *Witches' Brew* sign. I've got a shot glass collection from everywhere I've ever been. Who else has a South Bend, Nebraska, shot glass?

HOUSEHOLD DISCOVERIES: CIRCA 1914

Magazine covers—The cover designs and full-page illustrations of several of the leading monthly and other periodicals are reproductions of the best works of prominent artists and illustrators. These are freely used in many homes to decorate the walls of libraries, dens, and sometimes living rooms.

STATS
Location: New Jersey
4,500 square feet
4 bedrooms
4 baths
Art by David Lee Roth
Gene Simmons vomitizer
Fresh Gene Simmons blood in freezer

SEBASTIAN BACH

Maty Fernandez, associate producer: When Sebastian Bach pulled the blood out of the refrigerator, we all just took a step back. We didn't want to get remotely close to the blood. We were scared to shake his hand after. Downstairs, in his basement, he gave us his own Skid Row concert. He took requests and everything. He made his kids come down, but they were not giving him the time of day.

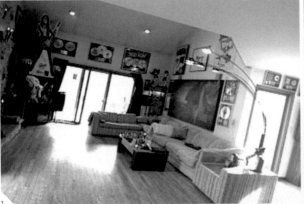

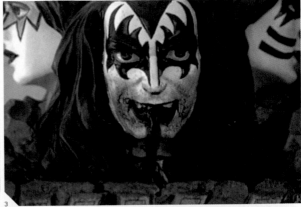

¹ This room is like the green house-slash-platinum house. I wanted something for my children. I didn't come from a house like this. I wanted to give them a life that I would have liked to have had when I was a kid. It's more for them. They're my buds. I love them.

Sebastian Bach's Design Tip

³ Every house needs a Gene Simmons vomitizer. I wouldn't feel complete unless I had a ceramic contraption that puked blood twenty-four hours a day.

² If you could have told me when I was twelve that I'd have a painting by David Lee Roth on my wall, I would have said: "No I will not."

⁴ I know I have something in my fridge that no one on this block has. The *KISS* reunion tour, when Gene spat blood, I have the cup he threw into the front row. Blood, still viscous.

📄 PROFESSIONAL OPINION

Sebastian Bach is living in his favorite comic book. He's got his superheroes surrounding him. He uses icons of rock and comics as inspiration for his own material and surrounds himself with that imagery. Clearly, he's very happy in his home. Like he said, he tried to create a world that his parents couldn't give him. What he's done is projected himself back into some self-created fantasy world. Julia Roth, interior designer

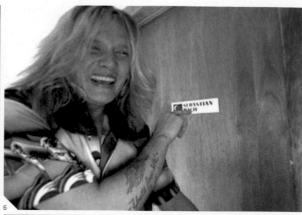

5 A collection of Seventies memorabilia.

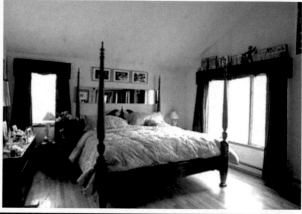

6 This is my bedroom. Please excuse the mess.

All bric-a-brac should be avoided. The fewer objects not actually necessary in the room, the better.

STATS
Malibu, California
7,200 square feet
4 acres
Pleasure palace with a Goth twist
Personal Starbucks
Japanese garden
Playground room with fuzzy walls club
Jacuzzi
Personal Studio
Bedroom with open shower and leather swing

TOMMY LEE

Nina L. Diaz, Supervising Producer: We got to Tommy Lee's house at 2 in the afternoon and didn't leave until 5 in the morning. He was so enthusiastic and was having such a good time. He had his guitar tech cook dinner for us. That's probably the most memorable shoot. We got such hospitality from him. He had the perfect party house and we stayed until the break of dawn.

Tommy's backyard is an amazing piece of heaven in the middle of the mountains. He's landscaped it to the degree that you feel like you've been taken on a tropical vacation.

You're looking at the backyard. We had the end-of-Ozzfest party here. It was crazy. There were 300 people in my house. People were naked in the pool. MixMaster Mike from the Beastie Boys was scratching. Imagine this with lots and lots of girls.

The Japanese garden, we have to be very quiet, very spiritual. Here is where we chill, we shut the whole world off. This is where you get your head back together from all the madness that happens in the mayhem. The sound of water is very good for the head. We like that here at Tommy Land.

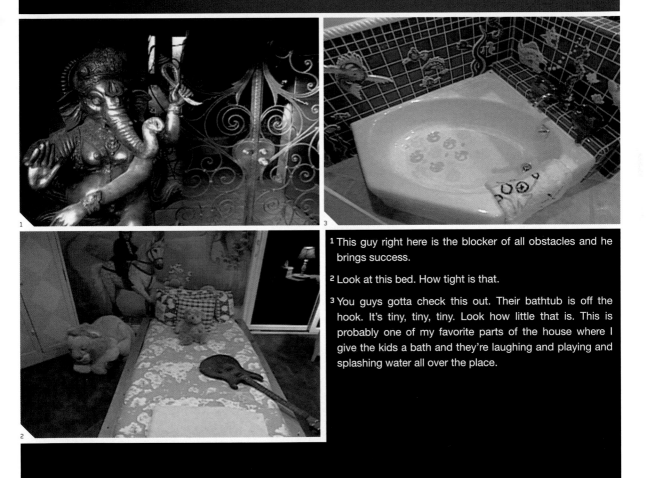

1. This guy right here is the blocker of all obstacles and he brings success.

2. Look at this bed. How tight is that.

3. You guys gotta check this out. Their bathtub is off the hook. It's tiny, tiny, tiny. Look how little that is. This is probably one of my favorite parts of the house where I give the kids a bath and they're laughing and playing and splashing water all over the place.

I think it's really marvelous to celebrate the elevator shaft. It's a fantastic use of space. Clearly, there's no surface of space in Tommy Lee's house that doesn't bear his mark. With the exception of his closet, Tommy Lee's home is stylistically consistent. Every room employs strong colors and luxurious material and a baroque delight in excess. Perla Delson, architect

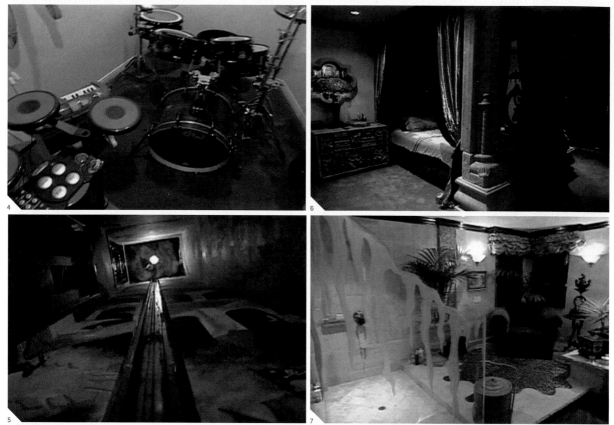

4 Dude! Drums! Acoustic drums, electronic drums, keyboard!

5 We're in the elevator shaft of Tommy Land. This goes from hell to purgatory, which is level two to heaven. Things get calmer and nicer as you go up to heaven, my bedroom.

6 We have arrived. This is heaven. My bedroom.

Tommy's Design Tip

Dude, if you're a pimp, you gotta have a mirror above your bed.

7 I pretty much designed all this. When I got this place, there was this wall in front of the bed. I was like: That's wack. I wanted the shower to be wide open, so when you're lying in bed you can watch your girl taking a shower. What a view.

8 This is called the Chinese basket. It's off the hook.

9 Pimp status with the fuzzy jacket.

10 I chill right here. Read a book, whatever. . . .

11 This is where we work. This is where we make the hits. This is the studio slash bar slash Starbucks. I got so tired of going down the street to get a cappuccino. I was like, "you gotta install some Starbucks love in my crib." The big drip makes one gallon of coffee in three minutes. And then on tap about three seconds off the console, beer . . . ice cold beer.

📄 BEHIND THE SCENES

The thing about the swing was that there was actually a girl in it at the time. We didn't end up using her in the shot.
Maty Fernandez, associate producer

Create a cozy sitting area to offset larger, sparer spaces. Using color and soft surfaces can create a soothing, warm atmosphere. It's important for your home to have a place where you can go, curl up, and be yourself. All you need for this is some plush dark fabric like velour or velveteen or even ultra-suede, pillows in various shades of one color (go for rich, sensuous hues like burgundy or deep blue), and some kind of floor covering—a shag rug is ideal. Pick a corner space, staple the fabric to the walls, throw down the rug and the pillows, and veg out! Julia Roth, interior designer

12 Right here, this is the purple room. The whole room is in purple velvet. *I Dream of Jeannie* bottle right here. Nobody ever makes it out of that room alive. Everyone falls asleep. Dude, wake up!

13 Check it out. This downstairs is club mayhem. This is where a lot of the music is made. My drum kit's there. My piano. We got smoke machines, beams of light.

12 13

Tommy Lee's *Cribs* Shopping List
Buddhas
Incense
Tribal drums
Hookah
Fishbowls
Goldfish
Rock gardens
Shag rugs for walls
Frosty mugs
Coffee grounds
Industrial-style percolator

STATS
Location: Atlanta, Georgia
7 bedrooms
4 bathrooms
Garage-cum-shark tank
Boom boom room
Dog-breeding kennel

OUTKAST'S BIG BOI

Big Boi from OutKast here.
Bachelor style.

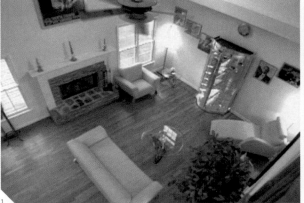

¹ I call it the living room. You might call it the family room. I've got my wall of Al Pacino, my favorite actor of all time. I've got my trophy case.

² This right here is the dining room. Red. I like red. Red is such a pretty color. The whole style of the crib is contemporary. To tell you the truth, I never ate dinner in this room ever in my whole life. I'm not even lying about it.

HOUSEHOLD DISCOVERIES: CIRCA 1914

Most men would agree with Eugene Field's remark that "almost any color suited him, so long as it was red." Hence, red is a suitable color for the furnishings of a man's room or den. The most pleasing effects in decoration are obtained by treating each room or group of connected rooms in such a way as to get a harmonious general effect or color scheme.

3 My son's bedroom. Just got something new, a Gucci baby carrier—it's fly.

4 My daughter's bedroom. Nice colors. To set the mood in the house, I used different colors. Player orange right here.

5 You gotta have surveillance. I lay in bed and watch who's coming in.

6 The boom boom room's where we have all the fun. The legendary pole is where some nice young ladies come to kick it after work.

STATS
Location: Boston, Massachusetts
11,000 square feet
5 bedrooms
5 bathrooms

JOEY MCINTYRE

I'll be showing you a piece of American history. This house was built in 1740.

BEHIND THE SCENES

Nina L. Diaz, supervising producer: Joey McIntyre actually knew about his house, which was great. With a lot of people, you assume they just hired a designer and that's that. I was really impressed with Joey.

Xionin Lorenzo, coproducer: Joey McIntyre had some place to be immediately after giving us a tour. But, we still needed to shoot b-roll. He and his people actually left us there in the house by ourselves. We were like: Should we lock up when we leave?

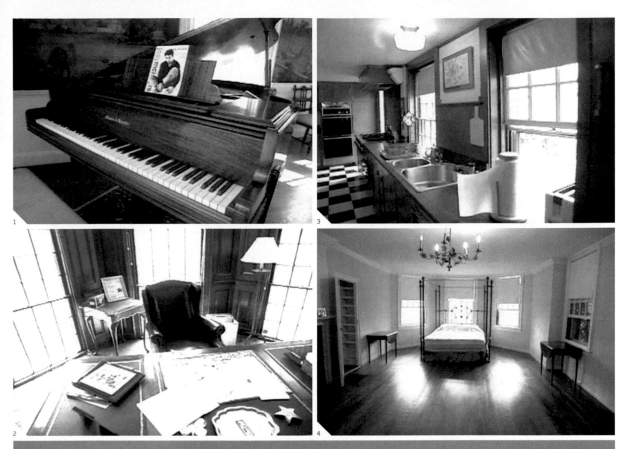

¹ This is a 1930s mahogany piano.

² This is where all my deals happen.

I bought this house when I was seventeen. I'm still young for the house. I tried to stay true to the vibe of the house. I think it's a special house. Sometimes I feel like I'm just the caretaker.

³ I'm a fly-by-the-seat-of-my-pants kinda guy. I don't have time to cook.

⁴ Where it all goes down, folks. If you look around this room, it probably looks like a guy in his late fifties lives here. I'm an old soul.

HOUSEHOLD DISCOVERIES: CIRCA 1914

To keep the piano or organ in good condition, arrange to have the atmosphere of the room dry. Keep the piano closed when not in use, and have it tuned three or four times a year, or oftener, if necessary. An hour or two of practice on a piano each day will keep it in the best condition.

⁵ To be out here and clear your head and remember where you came from. It's nice.

Sometimes I feel like I'm just the caretaker.

PROFESSIONAL OPINION

Joey McIntyre has an old house and sees himself as having an old soul. He has an affinity for heritage. He's using materials steeped in tradition; black-and-white photographs, Frank Sinatra, top hats. There isn't much color in his place. If someone wanted to achieve his look, they'd use a lot of dark wood, slightly classic retro furniture, paneling, black-and-white photography, antique fixtures, and natural lighting. Julia Roth, interior designer

Bedrooms should be preferably in light and delicate colors.

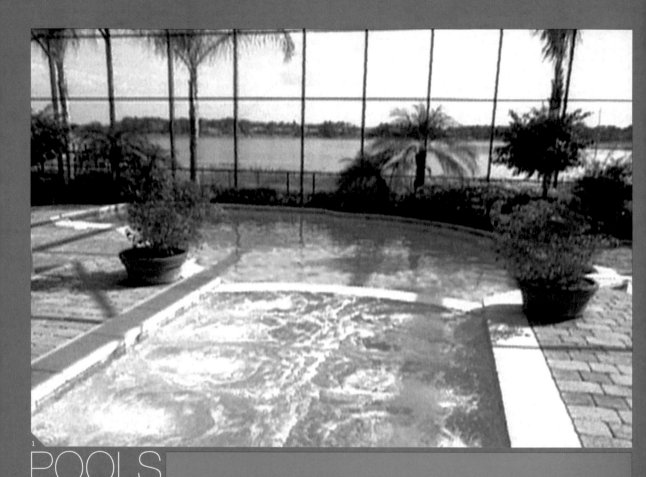

[1]

POOLS

Xionin Lorenzo, coproducer: As a producer, it's surreal to go and see these houses. It can also be depressing. Most of us live in regular apartments in New York City. How much these people make and what they spend their money on continually amazes us.

Like the pools—some of these pools are like the kind you'd see in hotel resorts. Bret Michaels had this stunning view, and this cool rock configuration.

[1] A.J. McLean

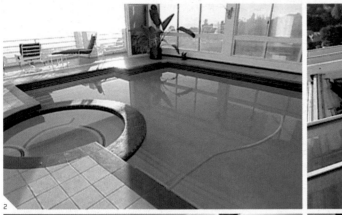

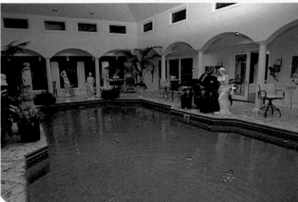

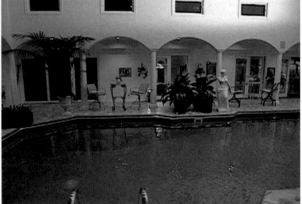

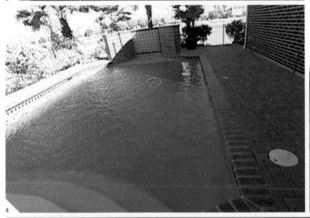

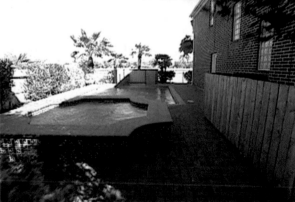

² Ice-T

³ **Missy Elliott:** I wanted an indoor pool because I can't be in no two-piece bathing suit outside. My neighbors would really bug out. If I do it in here, I'm good.

⁴ Lil' Romeo

55

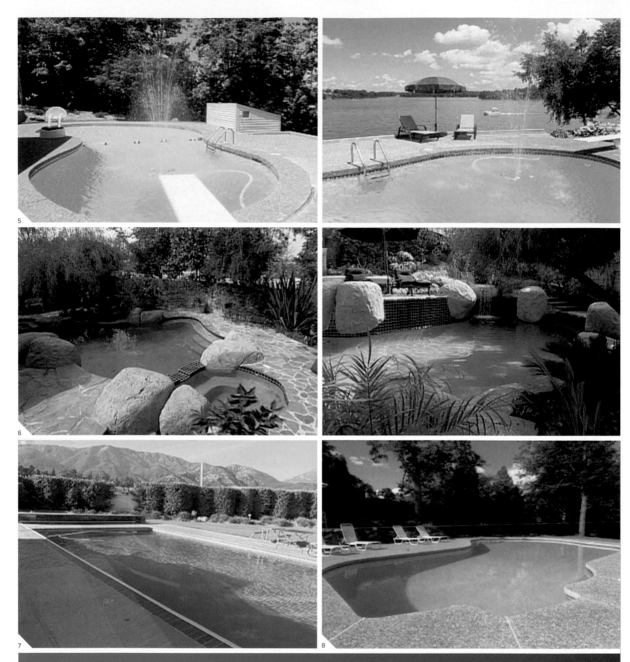

⁵ **Nelly:** We get it pretty crackin' out here.

⁶ **Melissa Joan Hart:** The good thing about this house is that it's made for parties. There's a little seat under the waterfall that's kind of fun. You can just sit there and hide under the water.

⁷ **Snoop Dogg:** Where the players like to kick it.

⁸ **Joey McIntyre:** Some day I'm going to do a video with the pumps and bumps and the rump shakers.

¹² Master P

¹³ O-Town

¹⁴ Penny Hardaway

15 Tony Hawk

16 Usher

STATS
Location: Malibu, California
6 bedrooms
5 bathrooms
Guest house with office and
dressing room/closet
Countless chandeliers
Outdoor bath

PAMELA ANDERSON

BEHIND THE SCENES

Nina L. Diaz, supervising producer: Pamela Anderson's house was very romantic and feminine. She was really open and very down-to-earth, talked about doing the cooking for her kids, and not letting them watch TV. She talked about how this house was her revenge on the men she's been with who haven't liked white. She actually put together the entire home. She said that if she ever changed her career, she knew she could go into interior decorating. She'd picked every little knickknack and it was very impressive.

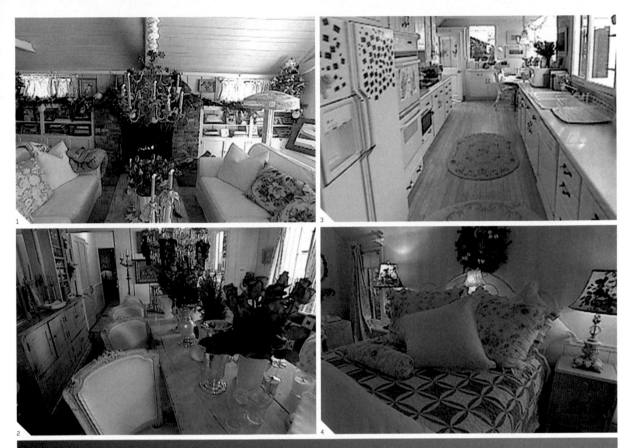

1 This is my little beach pad. This is the living room. I collect a lot of things. I'm one of those swap-meet whores. I collect pottery from the Thirties and Forties. I have some Italian chandeliers. I collect a lot of old antique blankets, really frilly stuff. I collect a lot of Depression glass and oil paintings. I like only oil paintings of flowers. I like some American painted furniture, but I really, really love the good stuff. I love wicker. I've decorated a lot of houses and this is my favorite so far. It's very feminine and bright white. I've always wanted to do this and so I finally got it done. I'm so excited.

2 The dining room is the place where I store things. We don't eat here a lot.

3 This is the kitchen. Kids' artwork is the decor. We have breakfast here every morning. When I'm not working, I don't have a nanny or a cook or anything like that. I like to do everything. It's fun.

4 The guest room. If you have a beach house, you always have a lot of friends for some reason. This is an old bed I had a long time ago, I had it refinished. I love this room. I think I like this room more than my room. It's very peaceful. It's very cool. The lighting is very nice. I come in here and read a book sometimes or sit with my kids.

I have to live on the beach.
Growing up on the beach is the best way to grow up.

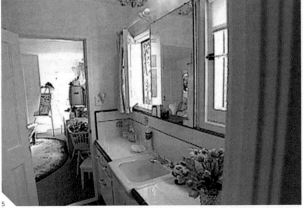

5

7

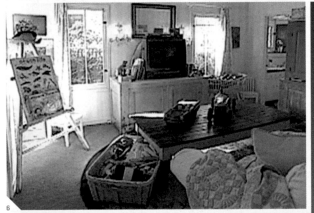

6

This is an old French bed, which I just recently broke.

5 This is the guest bathroom. I ripped out every light fixture in here and put all antique ones, old ones I've found.

6 This is the playroom. This is where the kids hang out. Toys everywhere. They like old toys. They're very into their antique stuff.

7 My room. Just simple and small. Some of my favorite pieces are up here. My TV and clips, and hatboxes.

The craze for secondhand or antique furniture is, on the whole, rather absurd. Very few persons indeed are able to distinguish a real antique from an imitation.

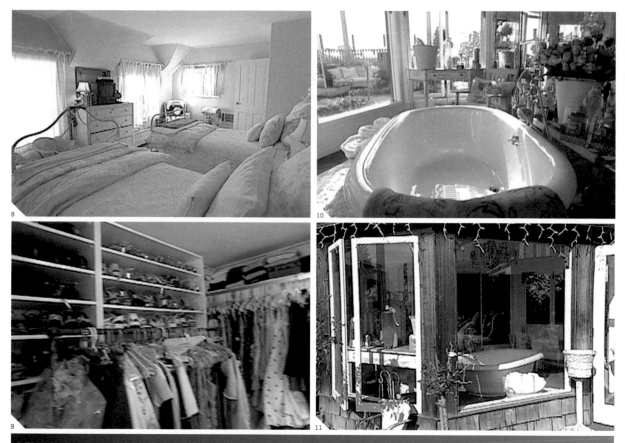

8 This is the boys' room, very close to mine. I sleep with them a lot. They sleep with me a lot.

9 This is kind of my kooky closet. I get to keep all my clothes from V.I.P., so you can imagine I have a lot, a lot, a lot. I have to have a little girl. I have the clothes for her.

10 This house has no baths. It only has showers. I can't have that with the kids [so] I created something fun out here. I always wanted to have a bathtub outside with a chandelier on top, so this is what I did. No one can see in, and if they do—whatever. Same vibe. All the stuff is from Provence; it's an Italian chandelier. It's really nice at night with all the twinkly lights all around. It's really beautiful.

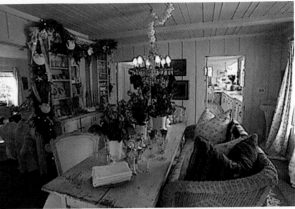

Pamela Anderson's *Cribs* Shopping List

Old crisp linens
Oil paintings with flowers
Depression glass
Needlepoint and hook rugs
Anything wicker
Chandeliers
Gilded picture frames
Handpainted ceramics from the Thirties and Forties
Antique crystal or glass hardware
Old French and American quilts
Fresh flowers (no dried flowers)
Bath oils
White towels

PROFESSIONAL OPINION

The house reflects Pamela Anderson's personality—white and fluffy and flowery. It's very clean and girly in a country kind of way, which is unexpected for the beach. The house is just dripping with white, but it feels clean and cozy, not sterile and clinical. If you're going to do an all-white look, it's good to have other, richer pieces to offset it—paintings, prints, pillows. She has a specific interest in rose patterns and such, but you don't have to.

HOW TO

If you wanted to get that look at home, well, you can paint just about anything white. Wicker, old furniture and antiques that have good lines can be inexpensively painted. You can basically whitewash any old furniture. Lightly sand and clean the furniture. Buy a latex water-based primer at the hardware store and paint it your favorite white. Benjamin Moore's ready-mixed colors has a great superwhite. And Snowflake white by Pittsburgh is really great. Dilute the latex with water for the whitewash look. Always use brushes, no rollers. You can dab with a rag or sponge for texture. Let it dry. For the last coat, add tea bags to polyurethane to make an antique glaze. Brush on top of the white. Julia Roth, interior designer

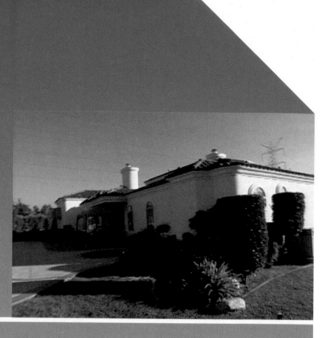

STATS
Location: Claremont, California
5 bedrooms
3 1/2 bathrooms
2 studios
Basketball court

SNOOP DOGG

I want to welcome y'all to my house, the dogg house. Slide in.

BEHIND THE SCENES

Nina L. Diaz, supervising producer: Snoop Dogg lives in this very idyllic, typical suburban enclave. He had two studios in his house. He was very domesticated. He's a daddy when he's at home. A daddy with a very big basketball court.

Snoop's a family man and the house seems fairly traditional in style. It's familiar and comfortable. Julia Roth, interior designer

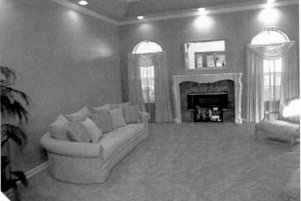

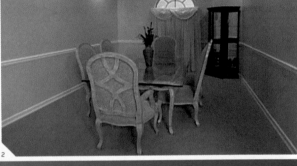

1 This is the room where no one gets to kick it at. It's called the untouchable room. Touch on the basis of untouchablism.

2 Don't nobody come in this room, neither. I'm usually in the studio or on the basketball court. All this area right here, the wife put that together, elegance and all. Look good, ya dig.

 HOUSEHOLD DISCOVERIES: CIRCA 1914

A hostess who takes her friends into a sitting room and tells them frankly that she prefers to "live in her own parlor" will have more friends than critics.

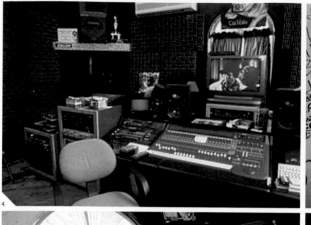

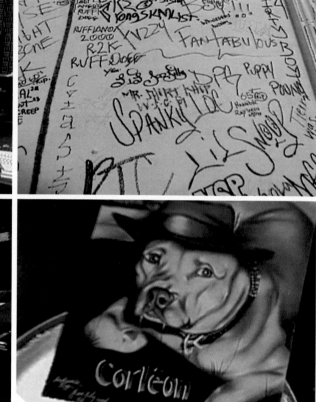

4 This is where it all go down at, where we create all the musical madness that we do. This is the wall of fame. Every gang-bang homie I've got comes here to sign the wall. Some of them still alive; some of them in jail for life; some of them still on the streets. This is where we represent.

5 That's my dog, Killer, rest in peace. He hung himself. That was my dog I loved the most.

Like Snoop, you can pay homage to your beloved pet with an artistic rendering. Go for a classic oil painting or get freaky and avant garde. Want your cat to look Cubist? Your dog to look Dali-esque? Check out the following websites:

www.apaintedlife.com www.poochesgracias.com
www.pet-portraits.net www.portraitsofanimals.com
www.petsinpastel.com www.stevetyerman.com

HOW TO

It's important for your family and friends to make their mark on your home. Make your own wall of fame like Snoop's. Use Crayola brand chalkboard paint on an unused wall in your house. Have people sign it, draw on it, whatever. Julia Roth, interior designer

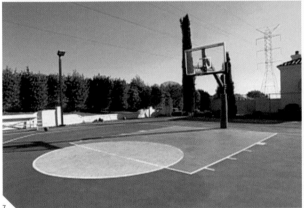

6 Here, y'all, this is the backyard in the wonderful world of Doggyland.

7 This is a real basketball court, y'all. It's quiet. Don't nobody bother me. I need to have a place where I can just relax. Inside the house there's so much energy and it's always off the hook. Here, it's quiet. They complement each other.

8 This is the section where we get our eat on. Chicken wings, French fries, macaroni and cheese. My wife does all the cooking.

STATS
Location: Miami, Florida
1,800 square feet
3 bedrooms
2 bathrooms
Pool

TRICK DADDY

Lemme show you how a real G lives.

BEHIND THE SCENES

Toni Ann Carabello, producer: Trick Daddy's house was crazy. There were all these women around, and I assumed they were people Trick Daddy knew. Well, it turned out they were hired models traipsing around in g-strings. He had them laying all over the bed and in the pool. Trick Daddy made us conch fritters and I swear they were the best things we ever ate.

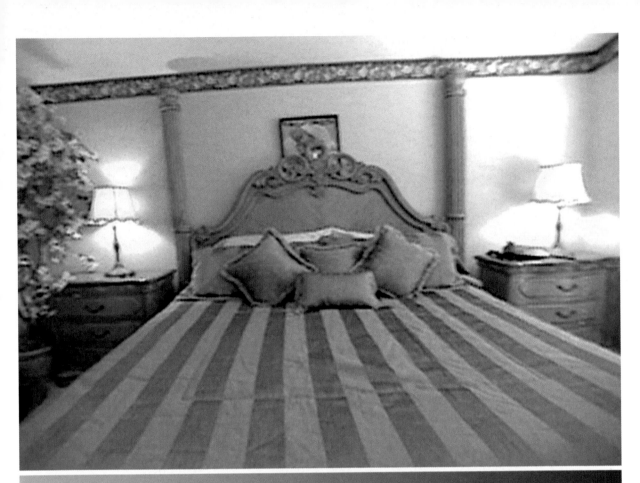

The bedroom. It ain't much.
I don't know how much it costs. I ain't got no receipts.

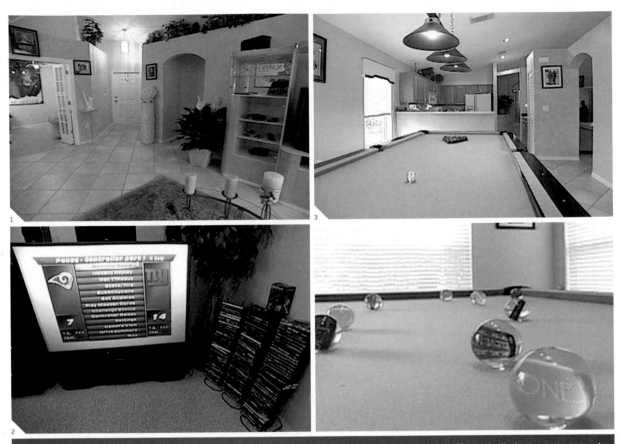

¹ See, this is where it really goes down. A lot of these plants get pushed on the ground late night when it's time to get down. Notice I don't have a door on my bathroom? I need to see what's going on.

² This room is strictly for PlayStation. We got all the DVD movies here—gangsta movies.

³ Here's the pool table area. These balls here cost a couple of hundred dollars. They're really a waste of money.

HOUSEHOLD DISCOVERIES: CIRCA 1914

Neat, tasteful and orderly homes have a very important educational influence.

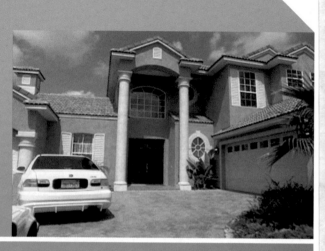

STATS
Location: Orlando, Florida
Pool
Flat-screen TV
Couch from <u>Making the Band</u> first season
Poolhouse/bedroom

O-TOWN

This is the O-Town house.
This is where we spend
most of our days.

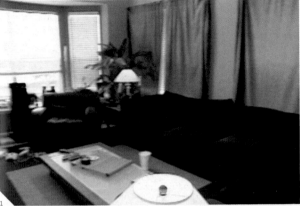

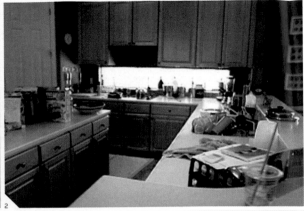

¹ This couch right here is where we were sitting when we got picked to be in the final five. We moved out of the original O-Town house, but we had to take the couch with us.

² The kitchen area. Cereal is the number-one food in the house. It always has been and always will be.

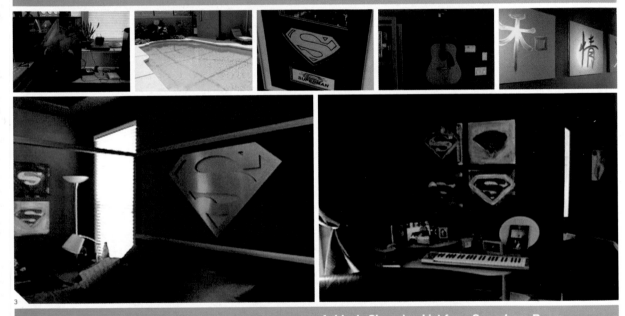

Ashley's Room

³ As you can see, my room has a certain theme, one thing I never grew out of was being the biggest fan of Superman. I have the actual S off of Christopher Reeve's cape.

Ashley's Shopping List for a Superhero Room

Old comic books
Old trading cards
Royal blue satin sheets
Old phone booth
Red cape-like curtains

⊓ HOW TO

Go one step further than Ashley and cover your entire room in comic books. Decoupage cut-out pages from comic books, trading cards, or stickers (or a combination) onto your wall. Glue-stick your chosen pieces to the wall, use a wide paintbrush to shellac clear varnish in matte or high gloss over the pieces. Let dry (drying time about twenty-four hours). Julia Roth, interior designer

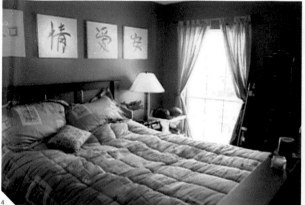

Danny's Room

4 I went with the whole Zen feel. The prints above my bed represent long life, passion, love and harmony. I like the whole candle feel. It's a really romantic thing to do when you've got someone in here, wink wink.

Danny's Shopping List for a Zen Room

Earth-friendly bedding
Mood music
Creamy, earthy paints
Area rugs in slate gray or foamy greens
Zen garden—create your own with a miniature sandbox and rocks from your favorite places!
Blow-up prints of Chinese characters

Trevor's Room

5 My small but spacious room. I'm a sports nut. I like basketball (that's my favorite sport) and I like golf. When I was thinking about my room, I decided I wanted this old-school golf thing going on.

Trevor's Shopping List for an Old-School Sports Room

Plaid sheets
Kelly green paints
Leather club chair (from a flea market, of course)
Old sports gear—lacrosse sticks, baseball bats
Trophy shelf
Wood accents like shelves or headboards or desks

Erik's Room

6 When I was thinking about concepts for the room, I just wanted something different, something I could call my own. I just went and told them: Paint a huge American flag mural on my wall. My pride and joy.

Erik's Shopping List for a Patriotic Room

World War II propaganda posters
Cowboy hats
Denim bedding
Red, white, or blue throw rugs
Paint one wall in red, white, and blue stripes
Paint a blue ceiling and stencil white stars onto it

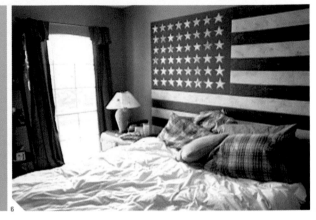

6

📄 PROFESSIONAL OPINION

Erik's got a good idea here. If you don't have a headboard, you can paint your own one on the wall. He did an American flag, but you could really do anything you wanted to. Brock Mettz, interior designer

Jacob's Room

7 I'm in the guest house. You have to walk across the pool area to get there. I wanted to be away from everybody. The walls have my collection of guitars. I used to build these guitars before O-Town. We all designed these rooms. I wanted to make sure I had a mural of the ocean.

Jacob's Shopping List for an Underwater World

Royal blue and teal paints
Fish decals
Aquariums
Sculptures of mermaid
Shells
Starfish
Paint your floor a richer, darker blue!

7

📄 PROFESSIONAL OPINION

Jacob's in the pool house and he uses water as an influence in his interior. That's a good place to begin decorating your house, using the outside to define the inside. Looking for ideas for your house? Look outside the window! Brock Mettz, interior designer

STATS
Location: Los Angeles, California
6 bedrooms
4 bathrooms
Go-cart track
Red sink
Spanish-tiled kitchen
Studio

BRET MICHAELS

Come on in, everybody.

BEHIND THE SCENES

Toni Ann Carabello, producer: He had this go-cart track where he raced his Jaguar. We actually hung out with him before we left. He cracked open some Dom Perignon and he and Ricki Rockett did a little jam session. It was fun.

¹ One thing I vowed growing up: I'd never have a living room you were never allowed to go in. My parents had that and I thought it was BS.

² The "Every Rose Has Its Thorn" guitar. The guitar that broke it all for me.

³ We put in this tile. Some call it tacky. I call it authentic. It's an authentic Spanish tile. For some godforsaken reason, I got this red sink. Some say because it was cheap. I say, because it was classy.

HOUSEHOLD DISCOVERIES: CIRCA 1914

The old custom of setting apart a "best room" or parlor to be used only on special occasions, as for weddings, funerals, or the entertainment of company, is happily passing away. Only very wealthy people now have the drawing rooms reserved for state occasions. The present tendency is to call all the lower rooms of the house "living rooms," and to have all the members of the family use them freely.

4 We took what should have been a closet and turned it into a very cool room for Rain, our baby, to have. We have a crib with a leopard-skin print. We built a place for her to change and do her whole thing.

5 It's important for me—in the room where you're making love, where you're with your girl—it needs to feel that way: the fireplace, crushed velvet. This is where babies are made.

6 We call it the rack.

7 It's about a rehearsal hall. It's about making music. It's about doing what you love.

STATS
Location: New York City
Trilevel penthouse
11,000 square feet
3 bedrooms
5 1/2 baths
Full-blown salon
Country kitchen
Moroccan room
Boutique-style closet
Mermaid room

MARIAH CAREY

BEHIND THE SCENES

Nina L. Diaz, supervising producer: There's so much stuff to covet in Mariah's house: her closet, the shoe room, her bathtub, those floors with the gold-leaf detail.

Maty Fernandez, associate producer: When we went to Mariah's house, we had to be careful about the floors. We had to wear little footsies—kind of like painters' smocks for the feet. Our steadicam operator couldn't wear those little booties and walk around with huge equipment. I had to run out and buy him a brand-new pair of nice Adidas that he got to take home.

We were there for a really long time, from nine to midnight. It was an entire half-hour show, so we were there three times longer than we might have been normally. She was really, really nice, and she had another interview after us. She was still chipper and outgoing when we left. She's amazing.

Viewers won't know we shot footage from Mariah's bathroom window. You could see Ground Zero clear as day from there. She actually talked about it, but we didn't end up putting it in the show.

I had dinner plans with my dad that night and I had to cancel because the shoot went on too long. I holed myself away in the laundry room to call him on my cell phone. He was like: "Where are you?" I said: "I'm in Mariah Carey's laundry room!" How many times in your life do you get to say that?

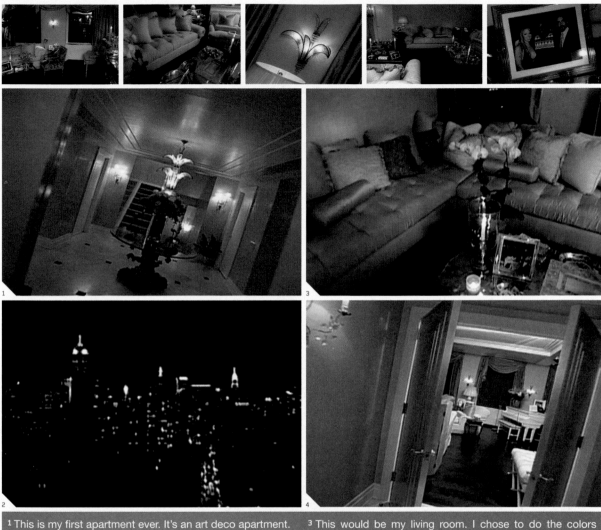

1 This is my first apartment ever. It's an art deco apartment. The walls are a process called glazing and I like that because they look like candy. It's tasty.

2 When I was little, I always wanted a penthouse apartment in New York City with a view like this.

3 This would be my living room. I chose to do the colors neutral, so they're not jarring. I have enough jarring things that happen on a daily basis. We don't need that at home. This is the relaxing, more serious part of my house. Most of my friends and I, we don't even bother coming into this area.

4 This is my private wing here. When I'm at home, I really don't wear clothes. I just wear boxers.

PROFESSIONAL OPINION

Mariah Carey picked a palette for her home that matches and flatters her skin tone. I think that's great.

Your house is like your second skin and as a general rule, it's good to have your house reflect your best self. Why not wear your interior space how you would wear your best dress?

Mariah's space reflects her and that's what everyone should strive for. You don't have to be Mariah Carey to mark your territory. Stake your claim on your space. You might not have the money to glaze your walls, but a fresh coat of paint can do the job, too.

It's important to have places of salvation in your apartment. It can be your bathroom or it can be your kitchen. Mariah has chosen the bathroom. As for her closets, well, closets are places for transformation. You go in as one thing and come out as something else. You close the door and leave the other persona behind. Celebrities have elaborate closets—it makes sense.

As far as the guest room goes, there is something to be said about all that print. If you're going to have a repetitive big print, go all out and do it just as Mariah has. Go balls to the wall. When used like this, the pattern becomes almost abstract. Take it over the top.

The Moroccan room is the stuff of storybooks. That kind of view is an event, and should be treated as such. Brock Mettz, interior designer

⁵ My favorite room in the house, the bathroom. When I come here, it's just like I relax, don't do anything for a little while, tell the world to leave me alone, kick everybody out.

I've only actually used the shower once in my life. There are too many knobs to figure out. The chandelier is one of my favorite things in this room. That's why we did the recessed lighting in the ceiling.

⁶ The one guest room I have. If you have too many guest rooms, fools like to stay over a bit too much. We could call this the butterfly guest room. I like the butterflies. This is a cute bedroom. One thing about it I like is that I have books from my fans here. The originality of my fans is unparalleled. They make me happy. So, we dedicate the butterfly room to the fans.

⁷ I get a lot of work done in here. It's the laundry room. Not many people like to admit they do the laundry. I also scrub the floors and do all the cooking myself. I'm quite a homemaker.

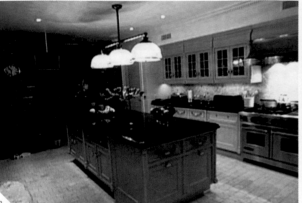

8

9

10

⁸ I wanted a country kitchen in the middle of the city.

⁹ The marble I selected is called butterfly. I liked it because it looks like it's butterfly wings if you look real close.

¹⁰ This is where I usually sit in this kitchen. I even eat in this spot. I have a rule against sitting up straight. I prefer to lounge, so I put this chair here.

⌂ HOUSEHOLD DISCOVERIES: CIRCA 1914

While waiting for the kettle to boil, for bread to rise and the like, drop down on the kitchen lounge and rest. It is just such little economies of strength that in the long run save time and preserve health.

It's how I chronicle my life.

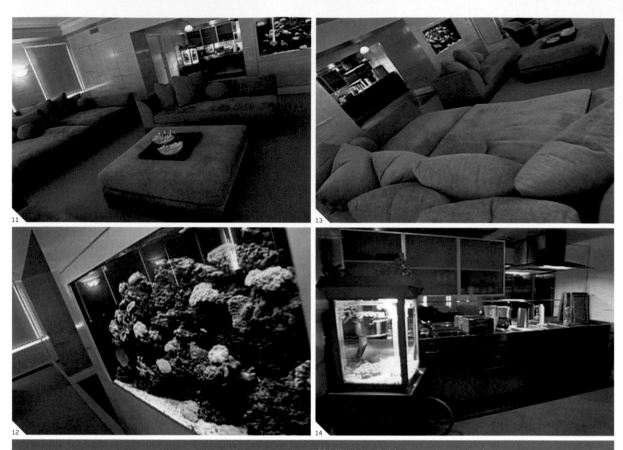

11 I like to call this room the mermaid room, but the mermaids aren't painted on the walls yet. People call me "Mermaid" because I like to swim. I got this fish tank and these salt water fish.

12 It's nice to come down here and see the fishes. The theme for the room is a pale blue under-the-sea-type thing. At night it looks really pretty. It's a very calming room and people say it's one of their favorite rooms in the house.

13 These sofas, you just lie down here and people fall asleep.

14 This area, this is just the kitchen for down here. It keeps everything contained in the mermaid room.

People call me "Mermaid."

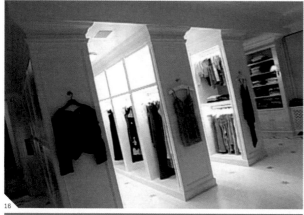

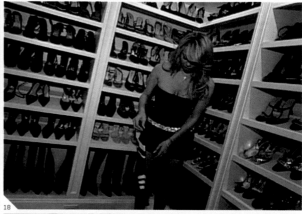

¹⁵ The place where I spend most of my time when I'm here: the full-blown salon.

¹⁶ This is my closet. As you can see, it's not really a traditional closet, but I worked hard for this mess.

¹⁷ We have gold leaf designs on the floor. That's a little "M."

¹⁸ This is the shoe room. There was a time in my life where I only had one pair of shoes. The girl who had one shoe, now has many.

¹⁹ The gym that rarely gets used. My brother put all this equipment in here. I really don't know how to use most of it.

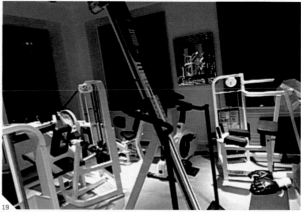

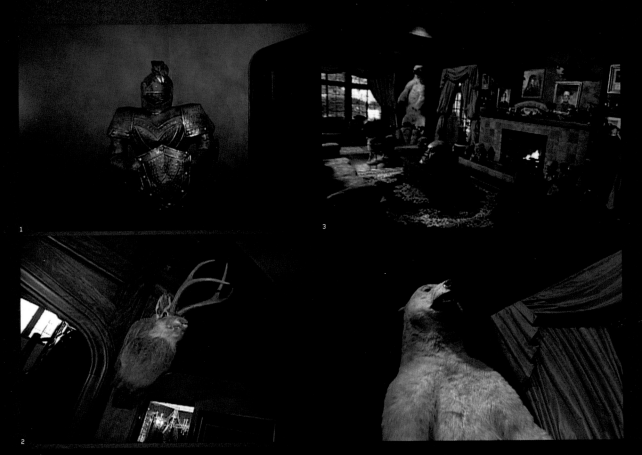

¹ In the entryway, we have our armor. Because every house needs a suit of armor. Every TV show I've ever seen—*The Munsters, The Addams Family*—there's always armor. Why? I don't know.

² The main thing in the front entryway is our jackalope. I hit that driving in Wisconsin a couple of years back. I felt bad for the guy, so I cut his head off and mounted him on the wall.

³ This is the living room. I don't know why it's the living room because there's a lot of dead stuff in here. The polar bear is from the original Addams family—not the movie, the real one.

Why let a good jackalope go to waste?

STATS
Location: Los Angeles, California
7,000 square feet
2 bedroom
4 bathrooms
Pirate bar
Beheaded jackalope
Gigantic stuffed bear
Nightmare Before Christmas-inspired
guest room

Come inside and I'll show you some weird stuff.

Erika Clarke, producer: Rob Zombie is into taxidermy and he enjoys collecting many things within the "horror" genre.

Everything has its place in his home; the man is organized.

The way he lives and the way he talks, he's not kidding. His hobby is his way of life. The minute you walk in you're like: Yes, I'm in Rob Zombie's house.

Dawn Reinholtz, production coordinator: Rob Zombie's house was Jekyll and Hyde meets the Munsters meets the Addams Family. It was absolutely wild. He told us he got mad at the gardener for cutting down his weeds. He wanted it to have an overgrown weedy vibe.

²⁰ This is the Moroccan room. It's very festive. It's like a fairy-tale room and that's why I like it. It's especially nice when you're looking at the view of Manhattan.

HOW TO

Moroccan style mixes unlikely colors and patterns and can be a lot of fun. If you want to create a Moroccan space in your place, you'll need candles, tons and tons of pillows, beaded cushions, mirrors, and furnishings painted in dramatic hues like orange, magenta, lime green, deep blue. A magic carpet wouldn't hurt either. Julia Roth, interior designer

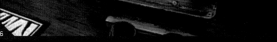

4 When I was in kindergarten, I went to Tijuana and this thing was in front of a sombrero store. Then, about thirty years later, I saw it again and I bought it.

5 This is a Chinese wedding bed. There's no nails, there's no nothing. It's like a giant jigsaw puzzle. It's very comfortable. Why wouldn't I sleep in this?

6 This is my electric chair. It doesn't work anymore.

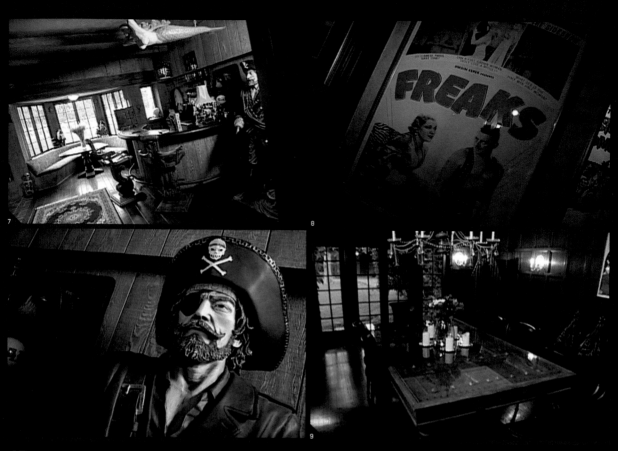

7 The pirate bar wasn't a pirate bar originally, but it looked like a pirate bar, so we made it a pirate bar. We've got our Captain Hook and our skulls and our Jolly Rogers and alll the things that make for a good pirate.

8 I got movie posters everywhere. That's what I collect.

9 Here's the dining room. We ate here once last year. We have our Halloween booze closet in here. There are a lot of secret compartments in this room.

Our Halloween booze closet.

10

10 Our thought for the bedroom was to make it look like a cross between a haunted mansion and a cheap whorehouse—and we succeeded! We went and tried to find every tacky thing we could find and it kind of feels like a guest bedroom at the Haunted Mansion. If you'll notice the ceiling, we had some guy in here forever. He painted a stormy sky on our ceiling. It looks pretty real when it's dark in here.

11 Here's another bedroom we have here. I had this brilliant idea before we moved in to paint the entire room like a mural from *Nightmare Before Christmas*. I put about a half an hour's worth of work in it before I decided that it was not a project worth pursuing.

11

⊠

Mattresses—The bed should not be softer than necessary for comfort, and the surface should be smooth and nearly level. The best material for mattresses is curled hair, although the much-advertised modern mattresses of felted cotton are also good and cheaper.

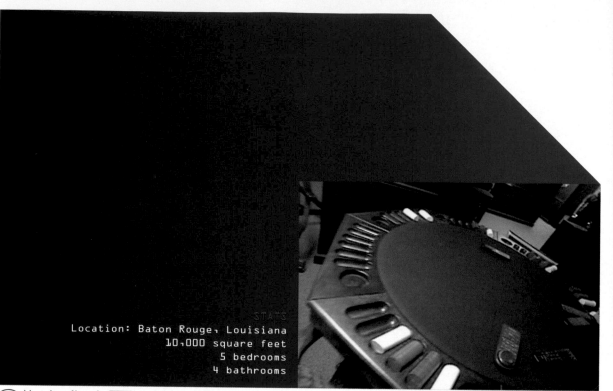

STATS
Location: Baton Rouge, Louisiana
10,000 square feet
5 bedrooms
4 bathrooms

SILKK THE SHOCKER

I don't have no blind spots in my house.

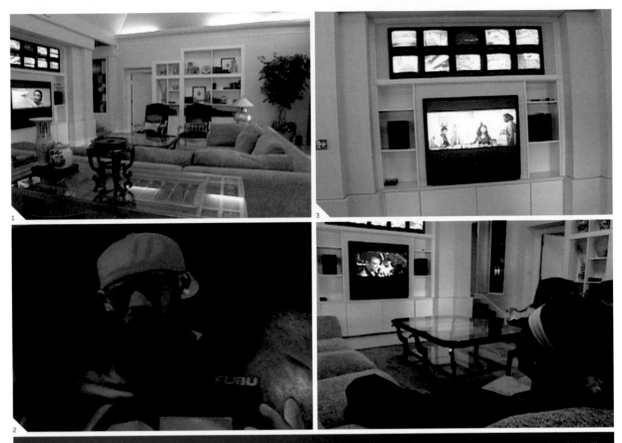

1 I designed it myself. I ain't the best designer, but I do like what I do.

2 This is a portrait of myself. That was when I was just coming up. It means a lot to me.

3 When I'm chilling, I gotta be able to see everything.

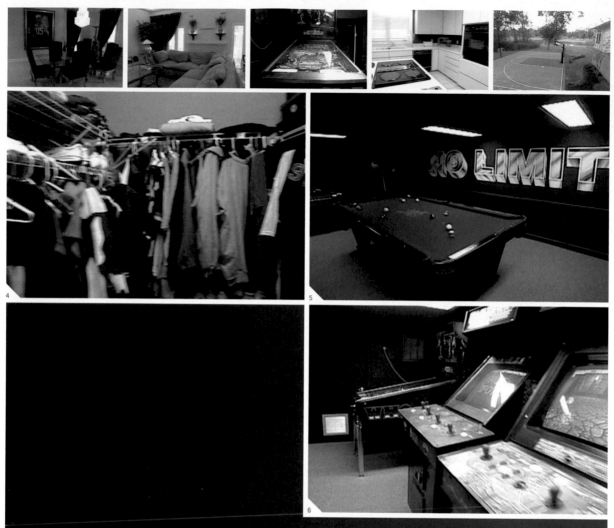

4 I don't do laundry.

5 This is where I spend most of my time.

6 My fun place.

```
                 STATS
  Location: New York City
        Duplex apartment
      11,000 square feet
             6 bedrooms
             8 bathrooms
               Waterfall
         Meditation room
          Deluxe TV room
        Antique warrriors
```

RUSSELL SIMMONS
& KIMORA LEE SIMMONS

Welcome to the penthouse.

BEHIND THE SCENES

Nina L. Diaz, supervising producer: The funny thing about shooting Russell's crib: He and Kimora had a very funny way of interacting. They were vying for who was going to do the touring. One time she put her hand over his mouth. We had to cut a lot of their arguments. They have a very playful way of communicating.

¹ Kind of an Asian influence. Kimora did the decor, influenced by her peeps. We bought the warriors at an antique shop. They're temple gods. We've got a bunch of artwork: a Barbara Kruger, a Francesco Clemente—he's one of the most respected, successful American artists, Romeo Abrito, my brother Danny Simmons. We've got a Ganesh.

🏠 HOUSEHOLD DISCOVERIES: CIRCA 1914

Ganesh is a major deity of the Hindu religion. The elephant head represents the world. His trunk represents the energy channels. His broken tusk represents the shedding of the ego and the single tusk represents the nondualistic nature of reality. The serpent that encircles Ganesh symbolizes the coiled energy of Kundalini (a smokeless, mystic fire which underlies all forms of life). Ganesh is known as the deity who rules the psychic forces within us, our path to spiritual elevation. Practice yoga, and those forces will be stimulated.

² I've got a meditation room. Every morning I come in here and put the DND (Do Not Disturb) on and just chill. I sit still for twenty minutes.

³ **Kimora:** This is our dining room. There is where the house shows its Asian touches. This dining room table is really great, because it's an antique Japanese door. The chandelier is gold leaf.

⁴ Our waterfall, I call our fish tank because we're very fickle about it. Running water is very important in life.

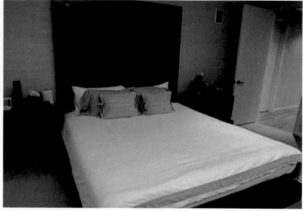

Russell's Design Tip

4 No matter how many rooms you got in your crib, no matter how big your crib is, you always hang out in your kitchen.

5 This is our master bedroom. Check it out. There are two TVs—a his and a hers.

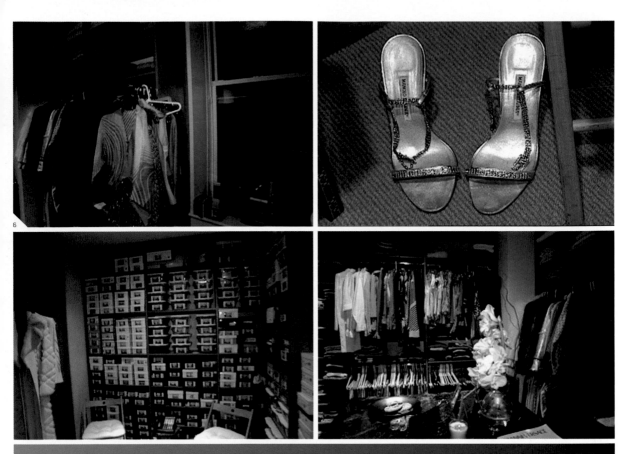

⁶ Kimora: This is my closet, my version of Russell's meditation room. No guys are allowed in my closet. I'm actually in the process of redoing my closet and getting a bigger one, double the size of my master bedroom. I have hundreds and hundreds of bags and hundreds of pieces of Louis Vuitton. I catalog my shoes by Polaroid and keep them stored in boxes. I have at least three hundred pairs of shoes.

 HOW TO

To create a dressing room in your room, you could buy a great mannequin at a retail supply store, partition part of your room with hippie beads, put up coat hooks to display hats and scarves. Kimora's way of organizing her shoes is borrowed straight from the fashion industry, but anyone can do it with plastic boxes and a Polaroid camera. Julia Roth, interior designer

7 Kimora: Ming's room is a great room. It's like an enchanted forest. There are women on the wall that look like Mommy. Daddy's on the wall meditating. It's an enchanted place we dreamed up when we were pregnant.

STATS
Location: St. Louis, Missouri
Lakefront property
4 bedrooms
5 baths
Boat dock

NELLY

BEHIND THE SCENES

Nina L. Diaz, supervising producer: Nelly was just coming off the *TRL* tour when we filmed his segment for *Cribs*. We actually arrived at his house before he did. The decorator had been there while he was on tour. We saw the house finished before he did. He got there and, off camera, asked us to give him a second so he could familiarize himself with his property. He had a huge smile on his face checking out his fish tanks and his stuff. He'd been on the road and was finally getting the chance to be in his home. He had gotten so famous while on the road, he'd decided to upgrade his home.

Kitchen cabinet—A good kitchen cabinet, with metal bins for flour, meal, and other substances that mice are fond of, is an investment which will save time and strength for the housekeeper and will be a moneysaver in the long run. These bins should be removable, so that they can be regularly washed, scalded, and dried.

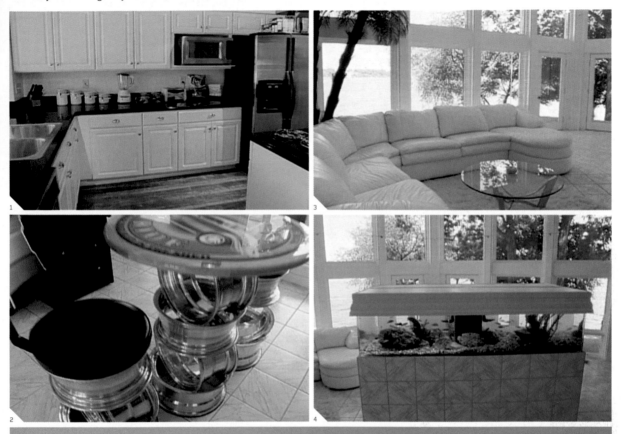

[1] This is the kitchen. For the single man, the microwave is the best thing ever invented.

[2] The table is made out of rims. I'm a big car freak.

[3] Where I came from, you never go in the living room. The white was something that let you know the living room was off limits.

[4] I got four fish tanks in the house. I'm just a real big fan of water.

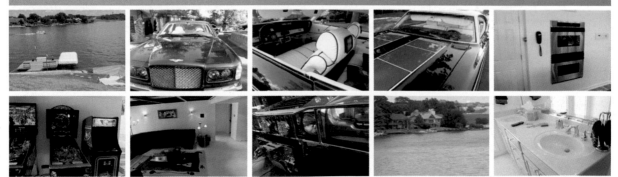

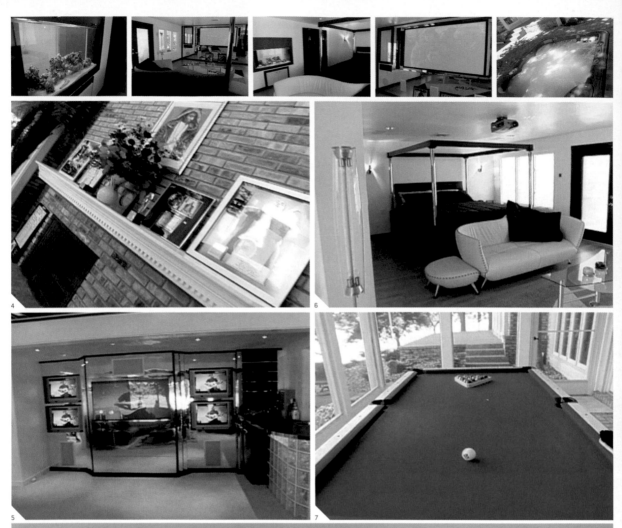

⁴ I didn't arrange this mantel. This was my mom's idea. "Put all my baby's stuff up there."

⁵ The setup with the TVs is that I can watch five different programs at once. I can control everything with a remote, sitting down like a lazy bum.

⁶ It's what they'd call, I guess, the master bedroom. I got eighty-inch projection. I like the fish tank in here, because you can see right through it into the Jacuzzi.

⁷ This is an outdoor pool table. It's made to get wet and still maintain.

BOY GEORGE

BEHIND THE SCENES

Erika Clarke, producer: We actually didn't show that in front of Boy George's house, he had fans' graffiti all over his bricks. There are all these notes written to him. You'd see stuff from 1984 from Japan.

Toni Ann Carabello, producer: I edited the Boy George segment. I had to cut out his closet. He had a crazy closet with all those big hats. There just wasn't time to show it.

This is my house, but you can call it a crib if you wish. It's a bit ethnic, a bit Gothic, a bit modern. It's a bit confused, like me. When I first bought this house, obviously I did some appalling things. I hung chairs from the ceiling and painted the walls pink. Over the past two years I've been redecorating and trying to make it more of a reflection of who I am now.

¹ This is my entranceway to my house. It's full of rubbish at the moment.

² This is an old fireplace I bought in a junk shop. It wasn't actually here, I just put it in. I thought it made the hallway look more homey.

³ This is my living room. It's just been decorated. It's sort of half-done. As you can see, it's kind of got a religious theme, crosses, very Catholic. People come in this house and think it's odd that there are so many religious references. But I was brought up vaguely Catholic. I think it stays with you. I think it's one of those things you can't escape. I'm not your typical Christian, obviously.

PROFESSIONAL OPINION

Boy George's house has spirit. There are lots of clean, hard, patterned surfaces, lots of rich color, a religious sensibility. Each room has a specific character piece and it seems very well-developed in terms of its concept. Although each room seems different, they connect well. Not everything has to match in a neat and tidy way. It's a myth that everything needs to "go." Boy George gathers radically different things in one room—a penis chair and a sleigh bed in one room, for example. The brass Victorian bath is a bold statement, especially when it's in a room with lots of glass and tile.

All these other cribs have a very American vibe. This has a different, European edge. It's almost sedate in comparison. Plus, the pieces borrow from religious and historical references. Perla Delson, architect

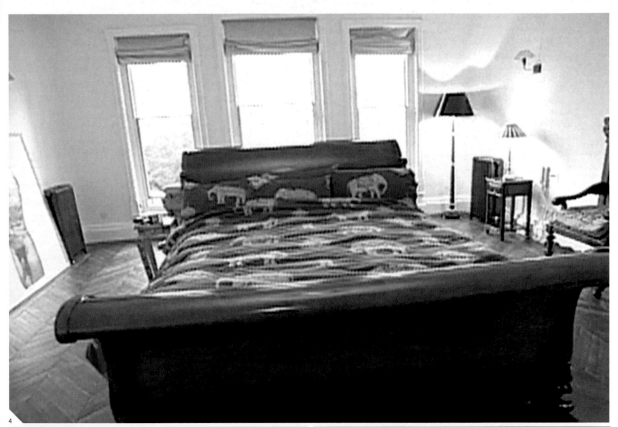

4 This is my favorite room. My bedroom. I spend a lot of time in here sleeping. Probably the most extravagant thing I've ever purchased is the bed.

5 I've got the very famous penis chairs. When you sit down, the penises go back. People normally sit on these chairs and put their hands on the penises and then realize and freak out. Why? It's wood. It's not going to harm you.

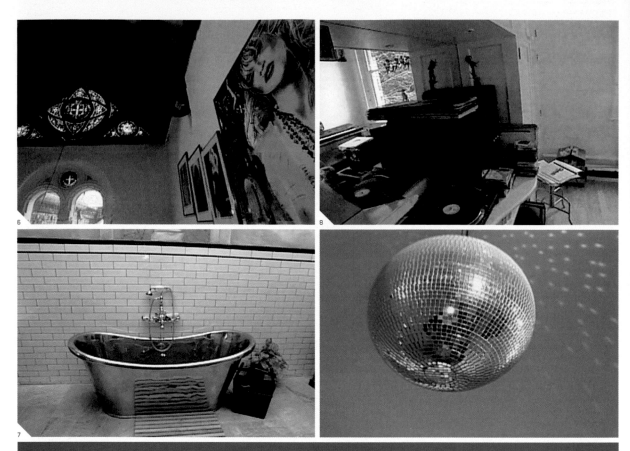

⁶ This wall here is my rogue's gallery. I have a huge picture of Madonna. I lived in New York in about 1986 and was walking down the road and went past this art gallery. There were two paintings in the window: one of Madonna and one of me. The guy in the gallery saw I was looking in, and said "Come in, come in." He asked if I would sign the one of me. I said "Okay, I'll sign the picture of me if you give me the Madonna one." He said: "Don't you want the one of you?" I said no. Why would I want a picture of me?

⁷ I think the word *decadent* would be a good word to describe this bathroom. I tend to shower, but if I've got time to take a long relaxing bath, I get in my Victorian brass bath. This bathroom was originally two rooms with a fake ceiling. We knocked the ceiling down and turned it into a glass roof.

⁸ This is my music room. This is where I come and listen to the records and get ready for my DJ gigs.

HOUSEHOLD DISCOVERIES: CIRCA 1914

Do not hang a picture in direct light, as exactly opposite a sunny window. When possible, a picture should be located with reference to windows and other openings so that it will be lighted as the artist intended; that is, the shadows in the picture should appear to be caused by the light that falls upon it.

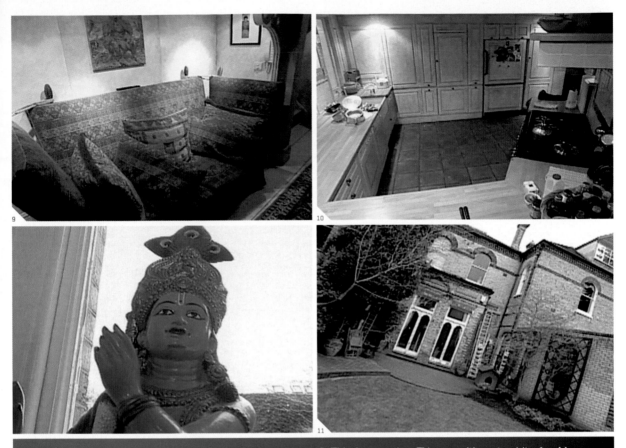

9 This is my other TV room. It's got a bit of a Moroccan casbah effect in it. There's a Ganesh that came back from India with me [see Russell Simmons, page 105]. This is really where I spend most of my time. This is where I watch *TV* and hang out with my friends.

10 One of the reasons I bought the house was because the kitchen was so big. I think the kitchen is the belly, the heart of the house. It's bigger than my mum's kitchen. That's why I like it.

11 It's a bit of a luxury having a back garden in London. We don't use it that much, because it's so cold.

CARS

1 Nelly

2 Bret Michaels

3 Ice-T

4 Lil' Romeo

5 Sebastian Bach

6-7 Usher

STATS
Location: Southern California
5,300 square feet
5 bedrooms
4 bathrooms
Tennis courts
Shared basketball court
Boat launch

TONY HAWK

Hi, I'm Tony Hawk. Welcome to my crib.

BEHIND THE SCENES

Erika Clarke, producer: Tony Hawk had a beautiful home with great memorabilia. He's a family guy, but you still get the vibe that he has a fun house. In the garage he has a simulator skate game that looked like fun. His mom was there and when we shot the b-roll, she bragged about how very smart her son was. She was so proud of him. That was the sweetest moment.

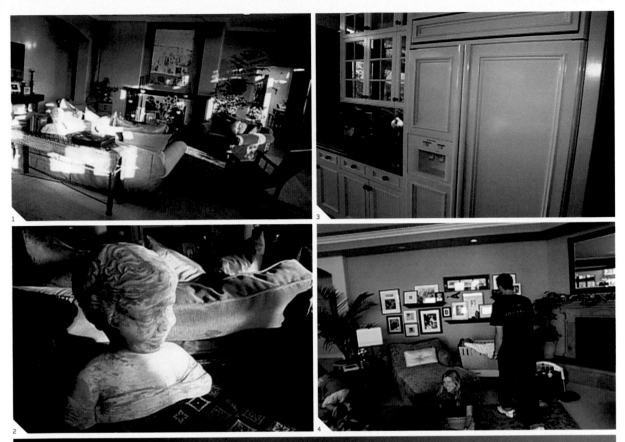

1 This is our living room. Don't be fooled by all the interior decoration. It's all my wife's influence. She's the artist. I just live here. My wife has this pillow obsession, so there's only so much room on the couch where you can sit. I don't even bother.

2 I don't know where we got this, but every time I come home and it's dark, it freaks me out. You look over the mantel and all you see is this head.

3 Our refrigerator in all its glory.

4 This is our family room. This is where all the action is all the time.

HOUSEHOLD DISCOVERIES: CIRCA 1914

Reserve for the privacy of sleeping apartments photographs of friends or relatives of the family; however interesting they may be to the owner, they can be of no general concern to those not members of the family.

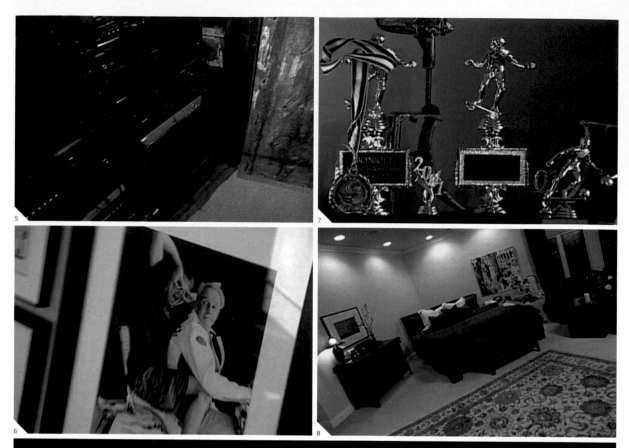

5 The control center for the whole house. VHS, DVD, laser disc, PlayStation and Dreamcast. A lot of wires through this house.

6 Our hero wall, so to speak.

7 This is my sanctuary. I've got X-games trophies

8 Our bedroom. It's big, if anyone comes to visit . . .

This is more normal than something you'd expect from a racy skateboard guy. But he admitted to having no participation in the design. It's stylish and comfortable, yet high-tech. What more is there to say? Julia Roth, interior designer

Hope you enjoyed our home.
We're gonna enjoy the sun.

STATS
Location: Hollywood Hills, California
10,000 square feet
5 bedrooms
5 bathrooms
Indoor/outdoor pool with moveable roof
Horror figurine collection

ICE-T

We're up in the Hollywood
Hills and it's all real.

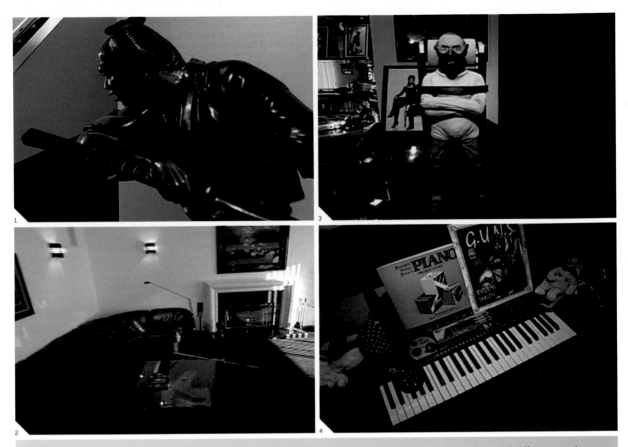

¹ This is the Ice-T inner sanctum. The first person you run into is my guardian. You heard about statues that come to life? If you steal, if you lift a grain of rice from my house, this cat will come and disembowel you for it.

² This is my living room. The best part of this room is the entertainment center coming down from the ceiling. This is where me and my homies kick back, watch movies and fights.

³ I'm really into figurines of horror people. If you can have a monster crew, who's going to hold down? Jason. Even Chuckie gets busy in his own way.

⁴ The leader and crown ruler of the domain, Little Ice.

5 Whenever you cross into any man's bedroom, it gets kind of freaky. The cool thing about this bedroom is that you can get up, walk flat out to a view, and yell: "Look at me! I'm a rapper!" You're yelling at Beverly Hills down there. A brother like me to make it up here is an accomplishment.

6 This is the recording studio. It's where we represent. Here I've got my shark tank. All of James Bond's villains had shark tanks. If I'm going to take over the world, I gotta at least start with a shark tank.

7 Something every house should have: a vending machine. You know how your friends are always in your kitchen eating your cookies and stuff. You want some Skittles? They're a buck. Stop begging.

PROFESSIONAL OPINION

Ice-T's place is a player version of a James Bond house. It's about domination. Only people who are sacred and trusted can enter the home and, even then, at their own risk. What's interesting about the house is that all the rooms unfold like origami. All the private rooms have glass doors and a hole to see the sky through. It can seem like many small rooms or one large open space simultaneously. The dolls are funny. It's as if he's found objects of supernatural icons and evil images to conquer in his own house. He's clearly the master of his domain and he can push a button and transform it. I'd advise him to go even more Bond. He's already got the shark tank. Well, James Bond had a fish tank that was also a king-size bed. All he had on top was a mink throw. Julia Roth, interior designer

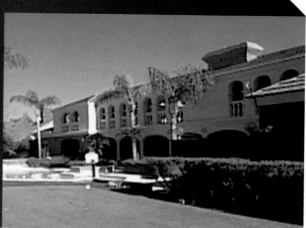

STATS
Location: Phoenix, Arizona
20,000 square feet
9 bedrooms
14 bathrooms
Two-lane bowling alley
Pool
Black-and-white photographs

PENNY HARDAWAY

Welcome to my crib. I actually bought this home in December of '99. We made a few changes to fit my needs.

BEHIND THE SCENES

Erika Clarke, producer: Penny Hardaway was so sweet. He was so nice and had such a tastefully designed house. He had a real movie theater with a popcorn machine and candy. We didn't even shoot the entire house. There was so much.

The kitchen, as the workshop of the house, is the room in which many housekeepers spend most of their waking hours. Hence, it should be perhaps the lightest, airiest, and most cheerful room in the house.

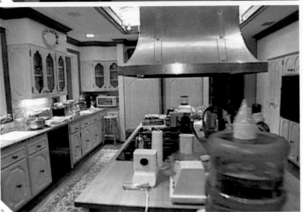

1 We're in the painting hall of fame. I wanted my paintings to be based on how I grew up.

2 The kitchen; that's my favorite place.

3 This is a very interesting picture. It's the best picture in the house. This is the house I grew up in. This house fits inside my bedroom. It was four rooms: living room, kitchen, bedroom, bathroom, that's it. I keep this here to remind me to never take anything for granted.

4 My very private bedroom. I have a sitting area and my bed, which I love dearly. My best friend, my bed.

5 I'm a clothes person. I have clothes from everywhere. Everything is sectioned off: the black shoes, the brown shoes, the boots, the tennis shoes.

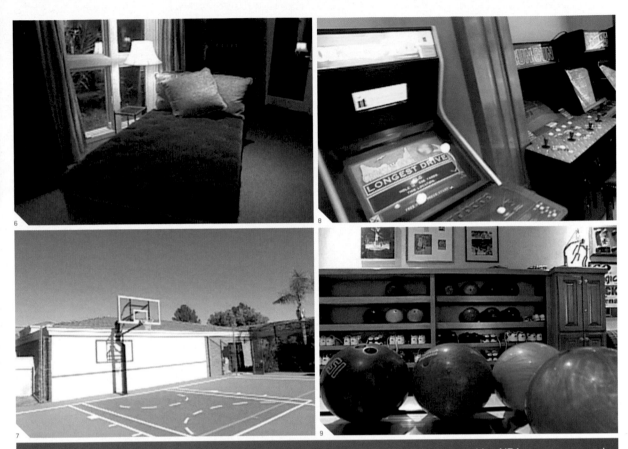

6 This is another sitting area off the master bedroom. I never come in here.

7 My favorite outdoor area.

8 The arcade. When I'm not watching NBA games or comedy movies, I'm either playing video games or lounging.

9 I've got bowling shoes in every size.

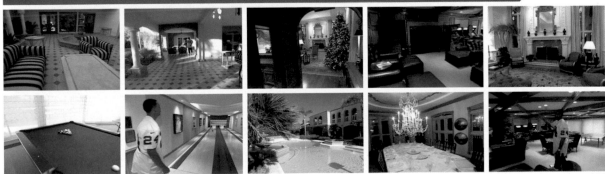

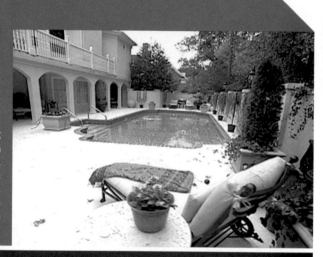

STATS
Location: Atlanta, Georgia
10,430 square feet
6 bedrooms
10 bathrooms
Studio
Salon
Pool

USHER

My humble home.

BEHIND THE SCENES

Nina L. Diaz, supervising producer: Usher kept canceling on us. He'd only recently bought the house, and he went through several incarnations in terms of the decor. There were so many parts of the house we didn't get to show. They're still under construction. He's got a salon and a full-on gym down there that he's still working on.

PROFESSIONAL OPINION

Usher's house has great bones. You could call it a neoclassical or neo-Greek home. In buying that home, he bought tradition. That he devotes a room to his mother is kind of shrinelike. That room is markedly different from the rest of the house, very feminine, with lighter, softer colors. He could have bought a superfab, modern souped-up house, but he chose something more staid. He seems to be all about heritage and respecting his elders. Julia Roth, interior designer

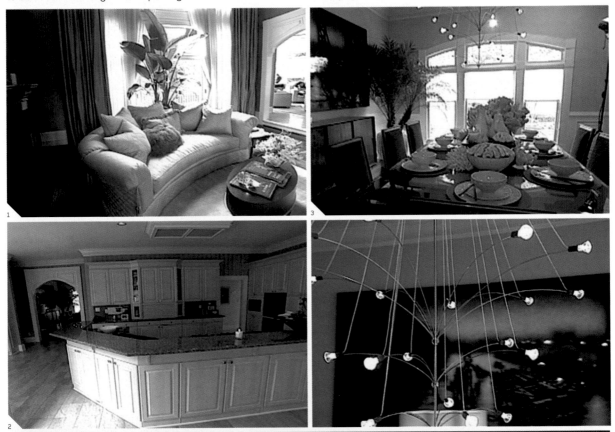

¹ My living room. I like to keep flowers in my house. I like to be at one with the earth. I have a lot of stones in this house. I name all of my plants.

² Here we are in the kitchen. I like to keep real healthy. That's how I keep this six-pack. My friends and I spend a lot of time here.

³ The dining room. We don't spend a lot of time here. That's why it's very nice and well set. The chandelier is funky and fun.

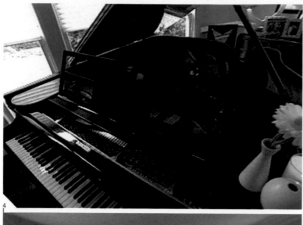

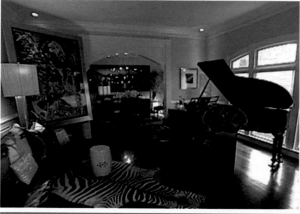

⁴ The best room in the house, the music room. Some of my most prized possessions are my photographs: Charlie Parker, Sarah Vaughan, Frank Sinatra, and Nat "King" Cole in a bar. I don't play piano, but I do have a lot of musical friends. We have a good time.

HOUSEHOLD DISCOVERIES: CIRCA 1914

For the music room, photographs of eminent composers and other musicians, or reproductions of paintings suggested by the use of the room, are appropriate.

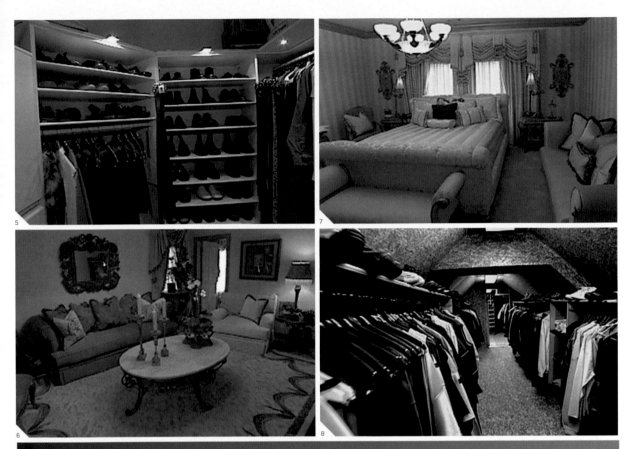

⁵ I collect mad Jordans. I have every Jordan ever.

⁶ My mother designed this room. It's real elegant.

⁷ This is my mother's area. She lives down the street. When she's not here, and I want to feel close to my mom, I sit in here. My mother's my best friend, my heart. I love her to death. Everything from the lighting to the textures is my mother in this room.

⁸ This is my cedar closet. Most of my tour clothing, I have here.

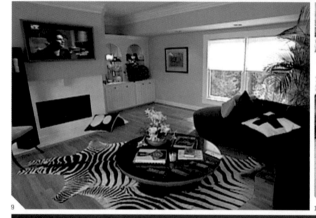

9

10

⁹ Here's where the party happens. You come in here and the music is blasting. It's all-out fun. This is where my guests come. You really have a good time. You gotta have a wide-screen TV. We have another kitchen area here.

¹⁰ That's my sofa. Nobody sits on that sofa but me.

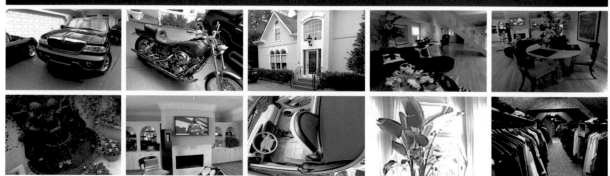

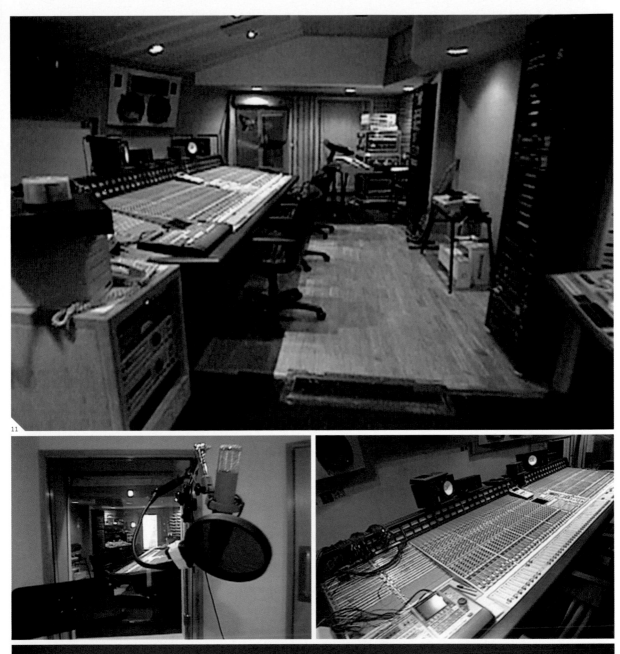

¹¹ This is actually L.A. Reid's old house. TLC, Pink, everybody has recorded in this studio. I remember being a kid, sitting up in the kitchen, saying, "Wow, L.A. Reid, someday I wanna own a house like this." And I ended up buying this house—ain't that something. I also utilize this for my own production. Me and Wyclef worked here, me and Jermaine. This is the hottest studio in Atlanta forever.

MASTER P

Welcome to my crib, you heard me. Come on in.

BEHIND THE SCENES

Erika Clarke, producer: I worked on the edit of Master P. It was for our first episode after the pilot. We were trying to get the tone of *Cribs* right. In a way, you could say that Master P set the tone for the show. His crib became the benchmark for others.

Nina L. Diaz, supervising producer: What you see is only a quarter of Master P's house, if that, We couldn't film it all.

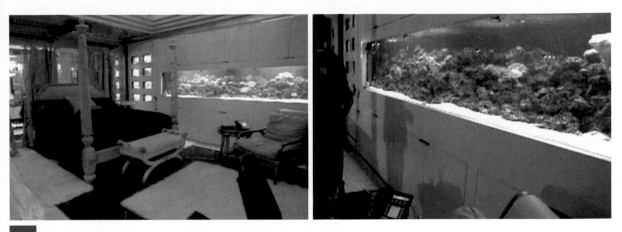

⊐ HOW YOU CAN GET A <u>CRIBS</u>-STYLE FISH TANK

If you want a *Cribs*-style fish tank, you need:

Custom-fitted tank (about $50,000)

500 gallons of salt water

1 fish per 100 gallons between $100 and $300 a fish. Tropical fish are the norm: eels, clownfish, jack fish. The life expectancy of a tropical fish can be ten years, but if you don't mix them well, they kill each other.

Shrimp and brine to feed them

Live coral, sand, water

$300 a month maintenance

I come from the ghetto and this is a long way from the ghetto.

1 Welcome to my living room. This is where all my family chill at. This is where the soldiers chill out. We have a lot of fun, watch a lot of TV. Most people go for the leather look. I wanted to go for the modern, soft type of feel. All the top of the walls are 14-karat gold. Chandeliers are from Europe, some are from Greece, some are from Spain. I've got the high-tech security system. I can control the whole house—the curtains, everything. Almost everything that happens in the house happens right here.

2 Where we feast at. A lot of stories get told in this room from all the good and the bad with the family. You thank the man up above that you know what we got, a chance to live in a place like this.

1

2

Master P's home is about excess. That fish tank in the bedroom probably cost $50,000 alone. I like the reference to King Tut and the elaborate accessories—the ornate chandeliers, the gold ornament. The Egyptian style he's emulating is polished black stone (look at the kitchen), tons of gold, precious stones and objects. Julia Roth, interior designer

³ This is the elevator. Had to get myself one of these in. When I be playing basketball, might be tired of walking up all those stairs.

⁴ A lot of people think you have to be in a big old studio to make your music. I like an atmosphere where I can feel it's more personalized. This is where I do all the high-tech vocals.

⁵ This room is fit for a master—the jewels and the chandeliers. This is all luxury. I got the idea from King Tut. This is one of the most expensive rooms in the house. This room right here is probably worth three million dollars.

⁶ This is the inside bath—all gold fixtures on the tub.

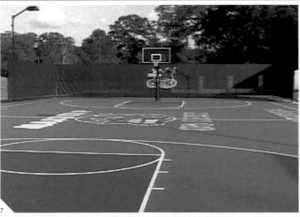

7 This is where I get my game on.

8 Sometimes I sit by the lake and just chill. Get away from it all—the media, the fans. I sit here and chill and reminisce and say: You came a long way.

If you wanted a room to emulate Master P's house, you'd need chocolate-brown glazed walls, gold-leaf (or sprayed, if need be) ceilings, a crystal chandelier that's as large as possible. Julia Roth, interior designer

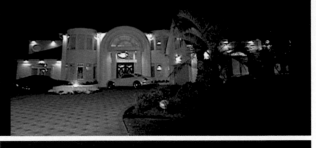

STATS
Location: Virginia Beach, Virginia
14,223 square feet
5 bedrooms
7 bathrooms
Ballroom
Gym
Movie theater
Indoor pool

MISSY ELLIOTT

I'm infatuated with the Greek feel.

BEHIND THE SCENES

Nina L. Diaz, supervising producer: Missy had a $350,000 custom Lamborghini that she wanted to bring down from New Jersey to Virginia for her *Cribs* segment. On the way down, it was stolen. When we got there, she teased us that we owed her $350,000. Her house was huge and built around that pool. They designed the pool and took the rest from there.

1 Now we're in the inside. You can't have carpet when you walk in a house, so you got to come in here with the marble floors, the marble steps. I had to have my signature in my floor—so that means ain't no one else staying here, unless they change the name.

2. The office, where my mother handles my business. You gotta do the office up right. You gotta have a big chair. You gotta feel like the big dog.

3 The conference room. I don't know who my mama be talking to, because she's the only one in here. You gotta love her. I'm infatuated with the Greek feel. You could be living in a one-bedroom and put a statue like this in your house. You be looking real large.

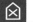 PROFESSIONAL OPINION

Unlike a lot of the other R&B stars, it seems like Missy Elliott actually uses a lot of her rooms. That said, she keeps them very dressy. What she spent on the house—whatever that number might be—she spent equal on the furnishings. I'd say it's a myth Missy's propogating that you can't have carpet on the floor when you first enter the house. Julia Roth, interior designer

HOW TO:

Other Things You Can Monogram (Aside from Your Floor)
Your sheets. Your towels. Your clothes. Yourself.

4 This is a room I don't even come in. Until you get on a real diet, never put a gym like this in your house. You'll be real sad and depressed.

5 My major little ballroom. My baby grand piano, I love to death. I always thought having a piano in the house was sexy. It's cozy with the candles and all.

6 The kitchen. I don't cook. I don't do nothing. I just do music. The kitchen table, you wanna feel like you got your own separate spot where you can just eat up. You don't have to worry about sharing. Everyone got their own thing going on. While you're eating, you can look in the fish tank.

7 Another sitting area. This is my Cinnabon pretzel chair. The fish tank is double-sided. We got naked ass all over the house with the Greek statues. And a lamp that cost a lot of money.

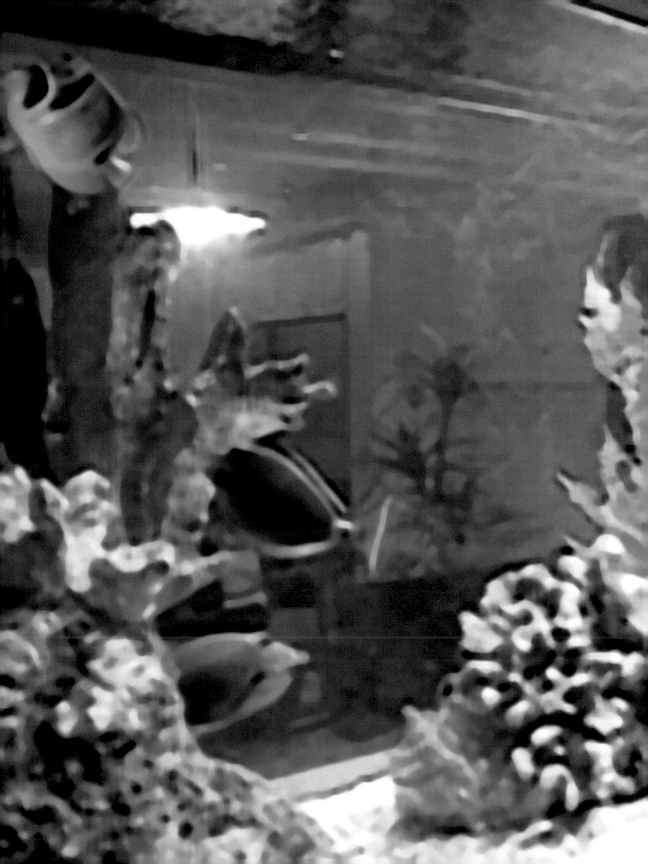

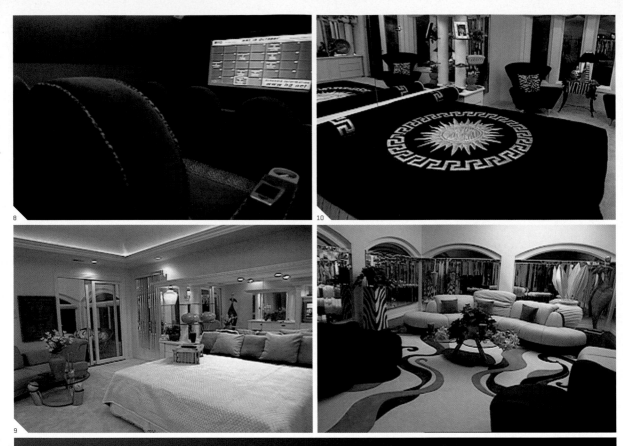

⁸ Who cares what movie it is when you can relax like this?

⁹ My mother's room. This is her little palace. There's a dual fireplace to the bathroom. This means a lot, especially when it comes to giving this to my mother. She did so much for me. I can never repay her for what she did for me. I can just say: A job well done. This is my thank-you to her.

¹⁰ This is my bedroom. Got your Versace bedspread. Got another sitting area. Got your mirror, blinds, a nice little swivel rug.

Missy's Design Tip:
Always keep a Bible. You must keep a Bible in the house.

STATS
Location: Orlando, Florida
5 bedrooms
4 bathrooms
Home theater
Pool
Dog named Vegas

A.J. McLEAN

Welcome to my humble abode.

BEHIND THE SCENES

Nina L. Diaz, supervising producer: A.J. was really sweet. He was very comfortable at home. He was walking around bare-foot, nurturing his new puppy. His thing was his closet. He kept saying: I'd rather have all these clothes than a bunch of vehicles.

¹ This is the opening foyer in my house. All these pieces of sculpture, my girlfriend and I picked out. We basically designed the whole house ourselves.

² This is my nice clean kitchen. I cook Burger King, that's about it.

³ This is the game room, which I like to call the Sinatra room. I'm a huge Sinatra fan. Frankie is just the coolest.

⁴ All the ladies at home, check this one out. This is my bedroom. This is the master bedroom suite with the big old columns. We had the spread all made. It's velvet.

5 I like to chill in the tub. We have the double-headed shower.

6 This is the master closet. My side is chaos and my girlfriend's side is nice and neat.

7 The best part of the house, my favorite part of the house, my theater. This is the best place in the world, where I come every single day and every night. By a single remote, I hit it and it fades to black and you watch a flick.

STATS
Location: Los Angeles, California
7 bedrooms
5 bathrooms
Boom-boom room

K-CI & JOJO

This place is peace of mind for us.

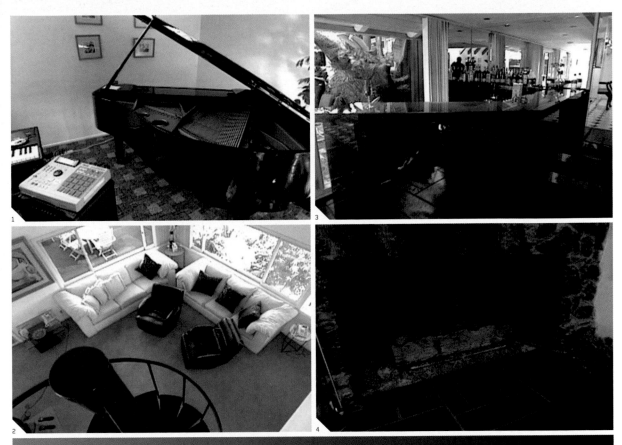

¹ This is where we make our music. It's smooth, right here.

² This is my little area where I kick it. The good part of this room is the window. I can see everyone when they come.

³ I be back here serving 'em up, serving 'em up.

⁴ K-Ci: What I love doing with this fireplace is light the fire with a remote control. Here is where I love to make love when it's real warm.

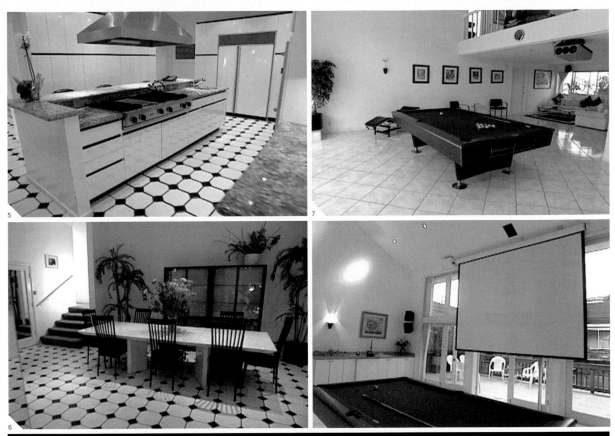

5 This is where it go down. We're living healthy, you see.

6 We sit around, congregate right here for Sunday dinner. This is the prayer room right here. When you walk in here, you gotta feel love. It's dedicated to God.

7 This is what we call the boom-boom room. This is where all the fellas hang out. Instead of going to a club, we might as well bring the club to us.

K-Ci: I just hope that I can be here for the rest of my life. This place is a peace of mind for us. I can't thank God enough for blessing us with such a lovely, lovely home.

LIL' ROMEO

Y'all know I'm only twelve so I still live with my moms and pops. I invested a lot of money in this house, so in the future I'll be all right. I'm a young Richie Rich.

BEHIND THE SCENES

Erika Clarke, Producer: Lil' Romeo, that one was a trip. Master P was there as dad, just making sure everything was cool. He wanted it known to the viewers that the kids' homes are in their names. Master P invests in properties and makes sure that the kids have their own homes. They live with him and his wife, but they each own their own home. That house is really for hanging out and recording. It needs to be known: that child is very intelligent and very polite.

1 My living room. I got the Picasso pictures, yellow, green, and orange men.

2 We call this the competition room, 'cause everybody's trying to compete.

3 This is where the losers sit at. When you lose up again, you gotta come sit here and wait your turn.

4 The winners sit in these chairs right here. I'm a winner, you know.

📄 PROFESSIONAL OPINION

I think this home is adorable. It's everything you'd expect from a twelve-year-old hip-hop mogul. It's a kid's fantasy house full of pop—pop colors, freezer pops. Fabulous. Julia Roth, interior designer

5 This is a mini-me of my dad's fish tank. He's got the big goldfish tank.

6 I got the chandelier from Italy. My dad got the bigger version.

7 I watch all the movies before they come out. I saw *Harry Potter* before it came out.

8 This is my home studio. I made my whole album in here.

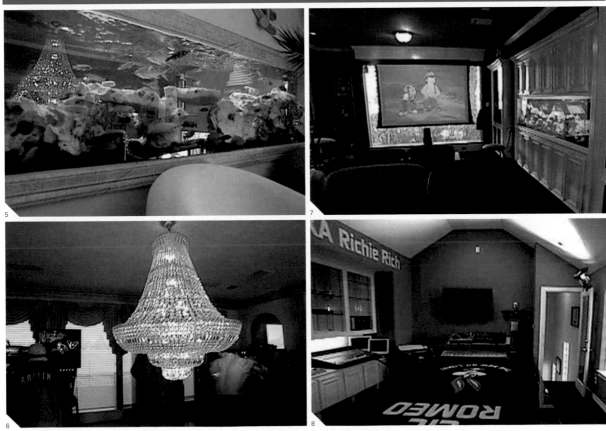

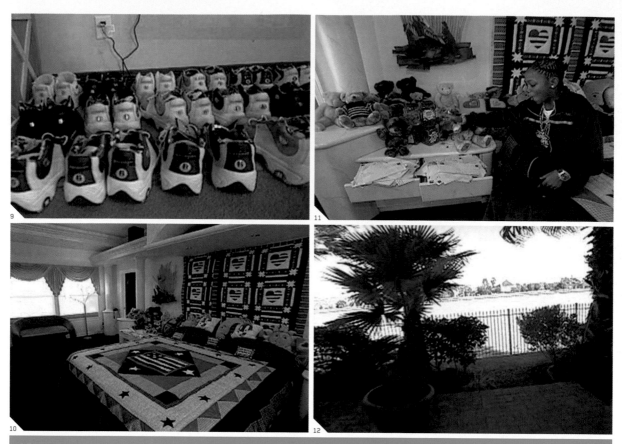

9 People always wonder why my shoes so clean. They don't believe me that I got a thousand shoes. I don't really know how many I have, but I think I'm good.

10 The master bedroom. My room. This room was custom-made for me. I got the American flag bed.

11 My fans gave me these.

12 A beautiful sight, as you can see. Just looking and wondering what I'm going to do next.

God bless America.

13

13 This car right here, I got this custom-made Romeo-style. I got the CD changer, the TV, the DVD. I got this all custom made—white interior with green. Richie Rich. These rims are all chrome. Twenty-inch rims. I ain't buying nothing else. We got PlayStation 2, we got the Game Cube and the Xbox.

BEHIND THE SCENES

Erika Clarke, producer: Yes, Lil' Romeo can drive. His mother let it be known that she doesn't let him drive around, just down the block. I admit I was a little freaked out when he got in the car and drove off.

Am I the first kid with a crib? Probably so! I gotta roll out and pick up my little Juliet.

Acknowledgments

Many thanks to all of the following people who helped bring this book to fruition.

Lauren Lazin, Nina L. Diaz, Erika Clarke, Xionin Lorenzo, Dave Sirulnick, Andrea Labate Glanz, Michelle Gurney, Lauren McKenna, Liate Stehlik, M. M. Nathan, Donna O'Neill, Linda Dingler, John and Darren at The Fold, Joann Foster, John Paul Jones, Hillary Cohen, Jim deBarros, Lisa Silfen, Donald Silvey, Walter Einenkel, Jeri Rose, Nicole Tourtelot, Liz Brooks, Beth Mohammed, Perla Delson, Brock Mettz, Julia Roth, Maty Fernandez, Toni Ann Carabello, Dawn Reinholtz, Janelle Hedstrom, and Mindy Lyons.

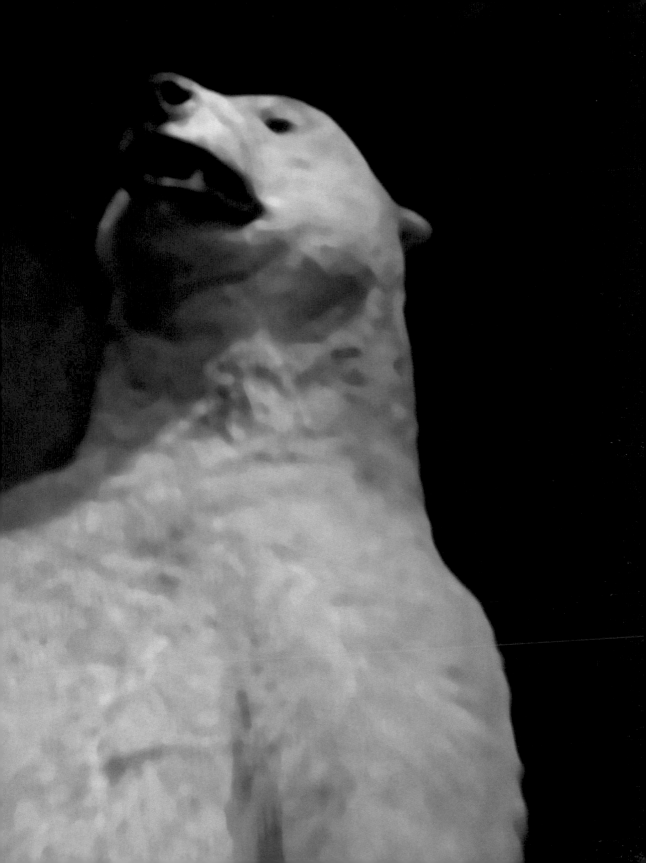